THE SHOCKING HORROR COLORING BOOK

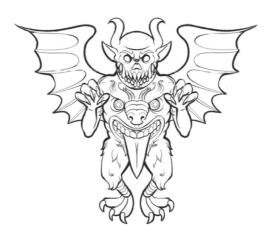

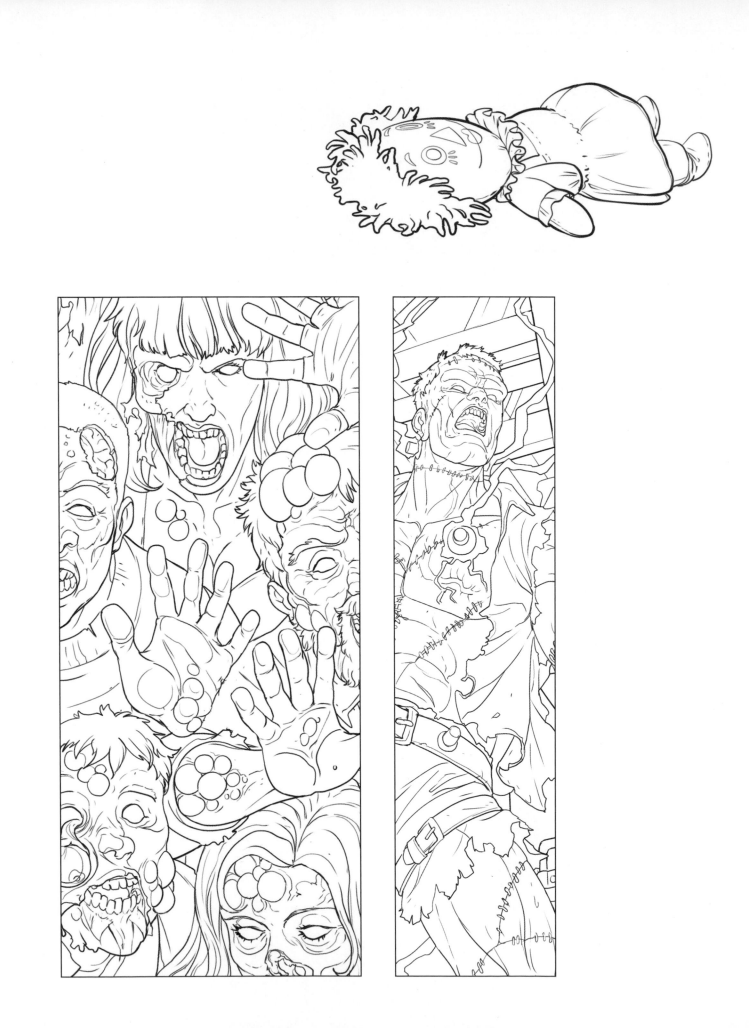

THE SHOCKING HORROR COLORING BOOK

JUAN CALLE AND SANTIAGO CALLE

SIRIUS

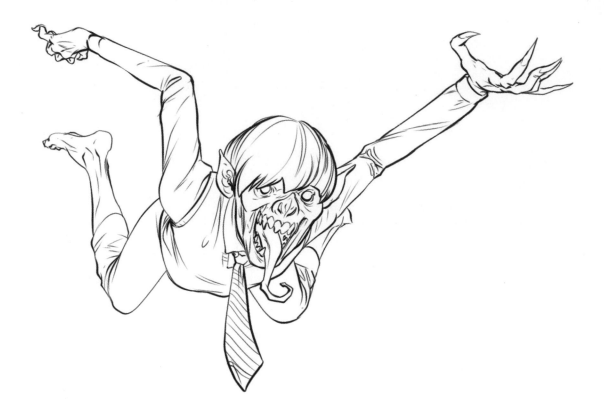

SIRIUS

This edition published in 2023 by Sirius Publishing, a division of
Arcturus Publishing Limited,
26/27 Bickels Yard, 151–153 Bermondsey Street,
London SE1 3HA

ISBN: 978-1-3988-3019-6
CH010961NT

Printed in China

INTRODUCTION

Welcome to fright night. From giant creepy-crawlies to giant clowns. From the living dead to the apparitions of your worst nightmares. Whether you lean more towards mythological creatures like werewolves and snake-headed Medusa, enjoy the disturbance of ghosts and ghouls, or have a desire to be possessed by evil spirits, this collection of horrifying images has something for every Halloween and scary movie lover.

Including sinister monsters, demon priests, melting faces, boil-covered creatures and images that range from teeth mandalas and demonic patterns to medieval depictions of horror, this book has many terrors to make you look over your shoulder.

Make sure you're armed with a blanket as well as your coloring pencils, lock all the doors, and switch on all the lights, and get ready to enjoy the thrills within the pages of this shockingly horrifying coloring book.

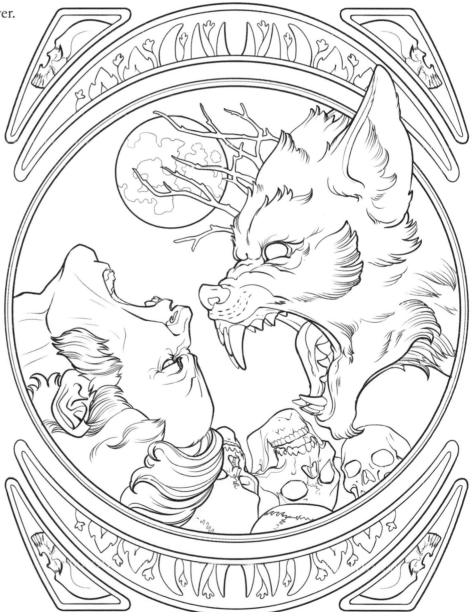

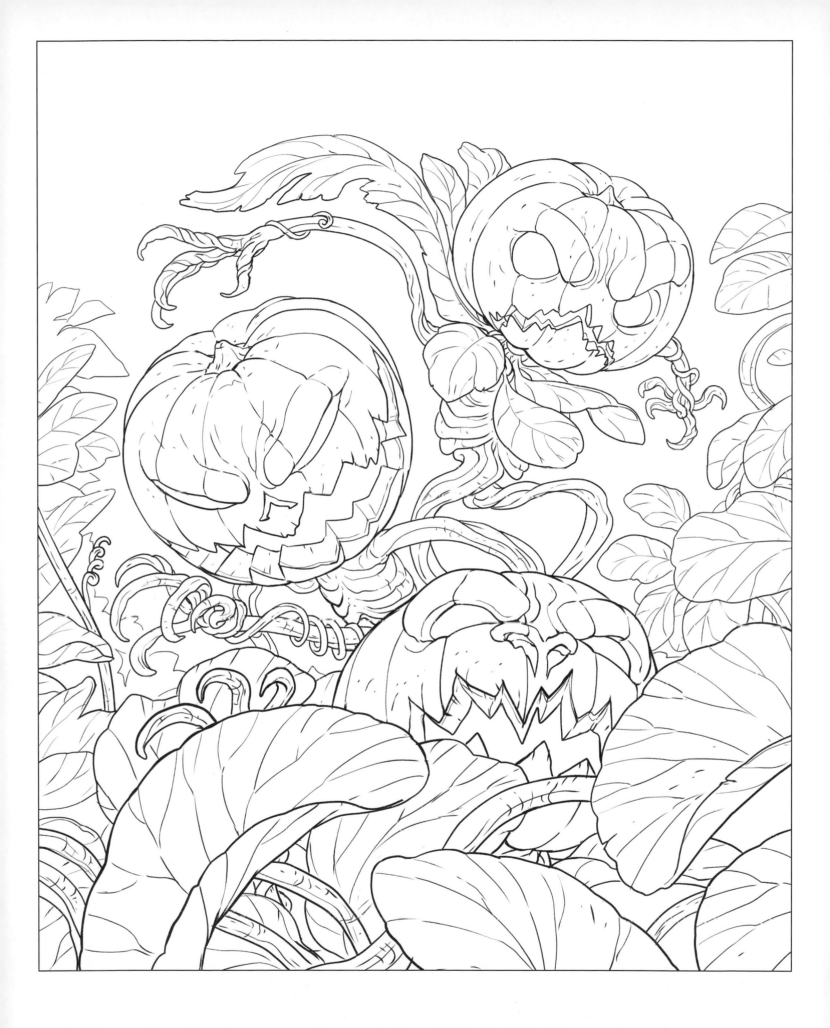

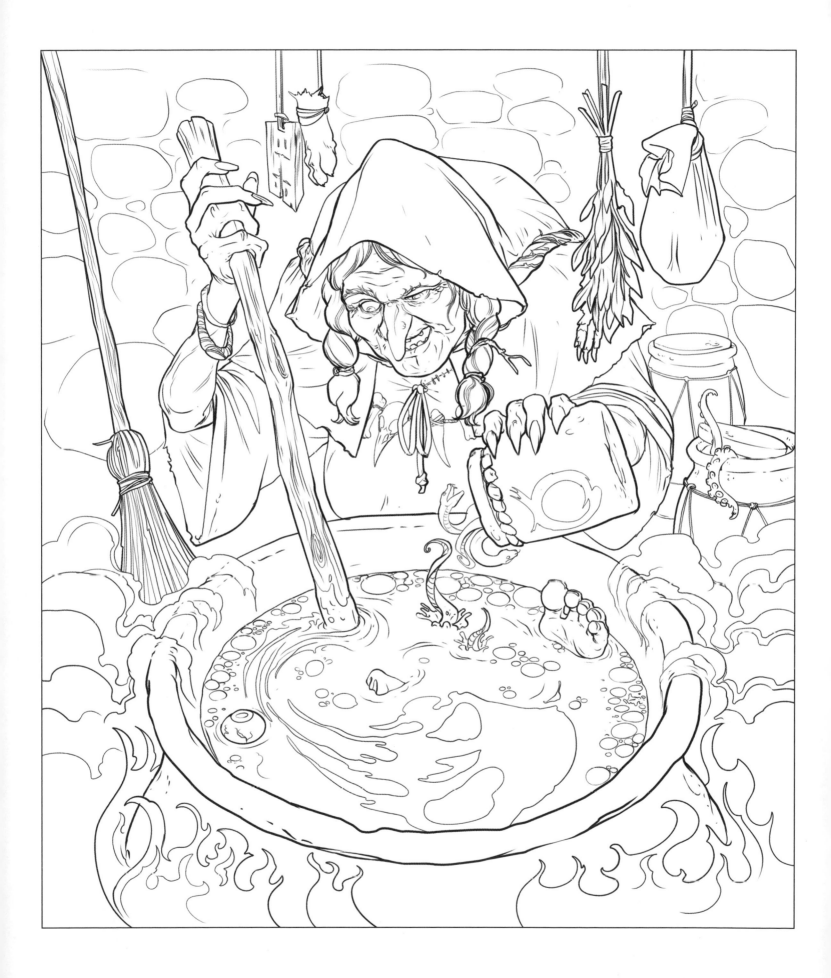

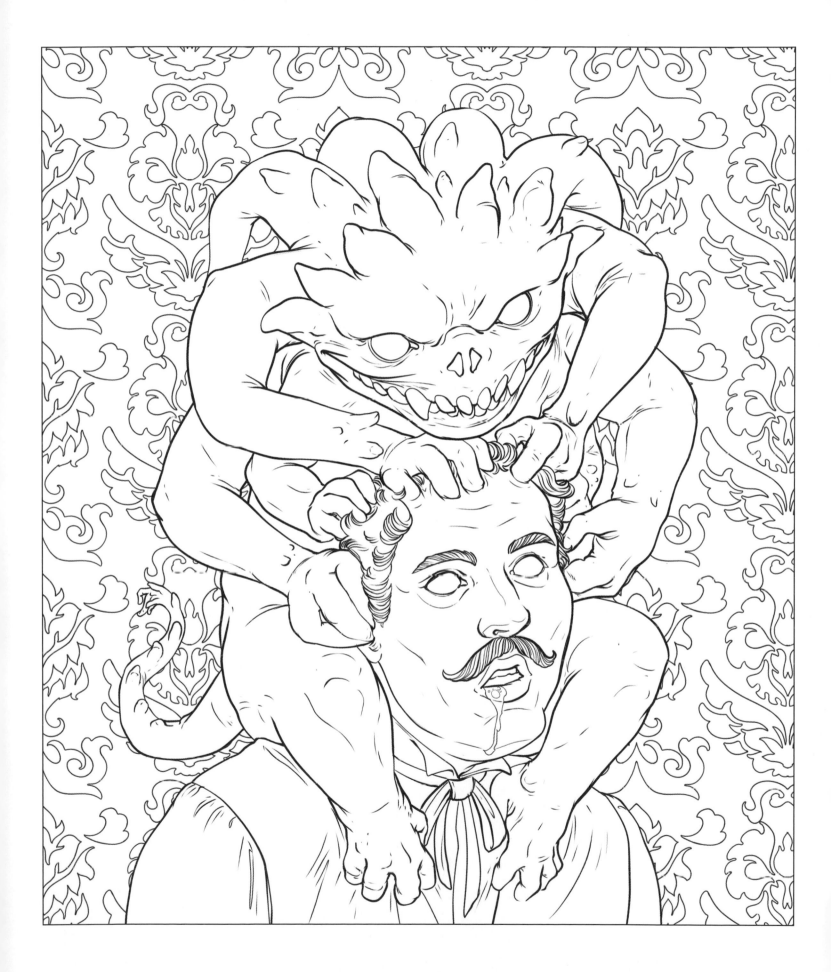

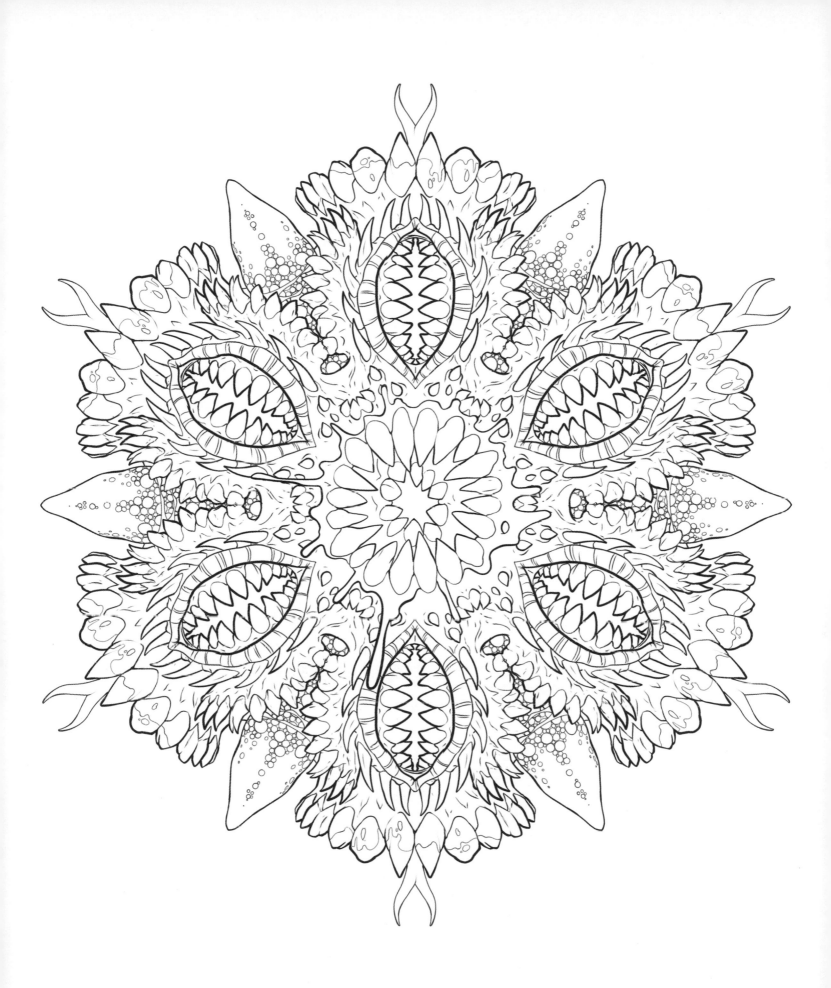

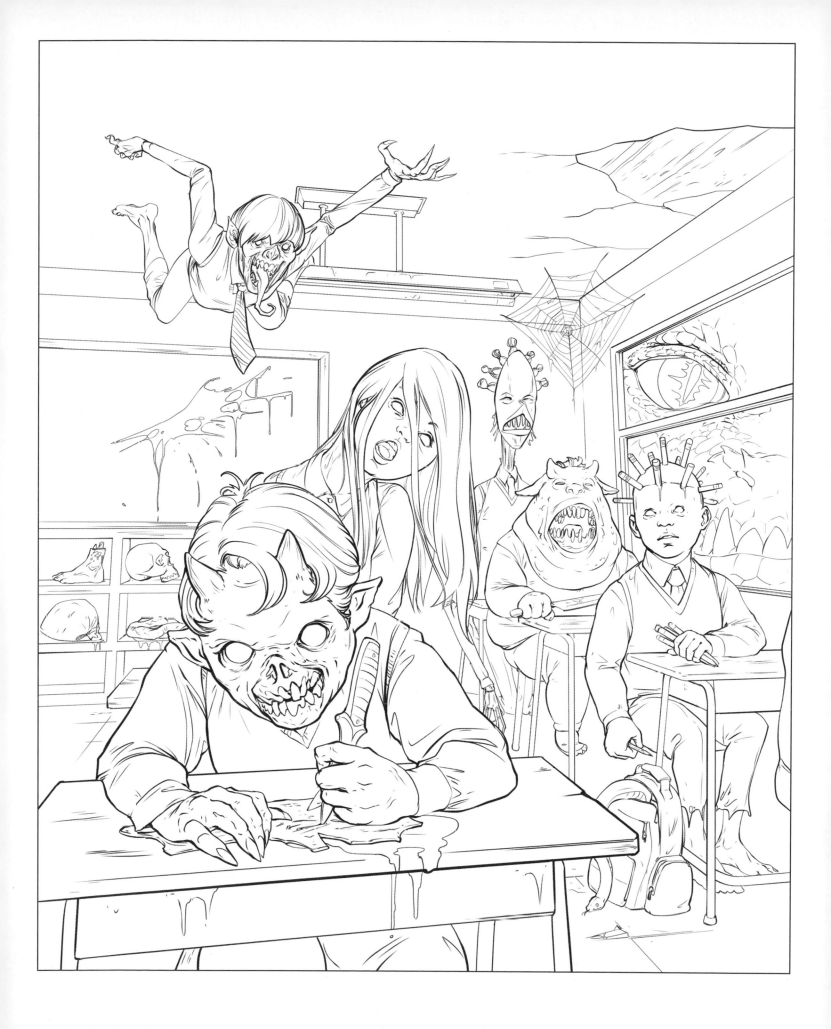

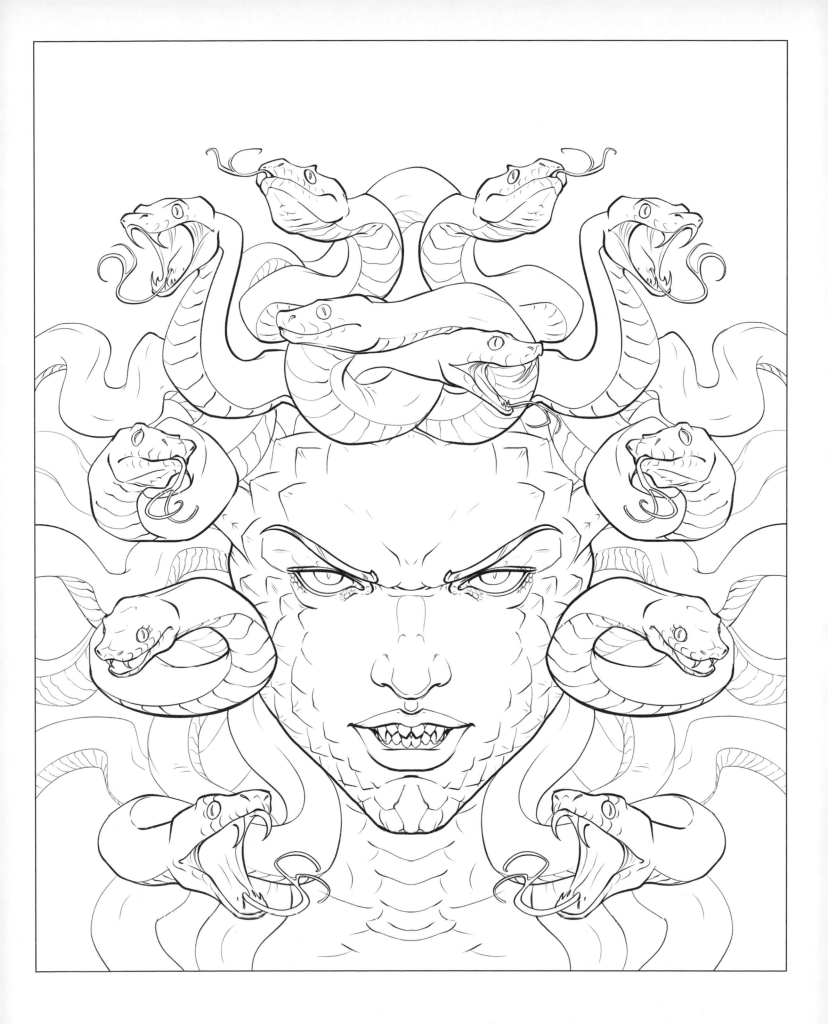

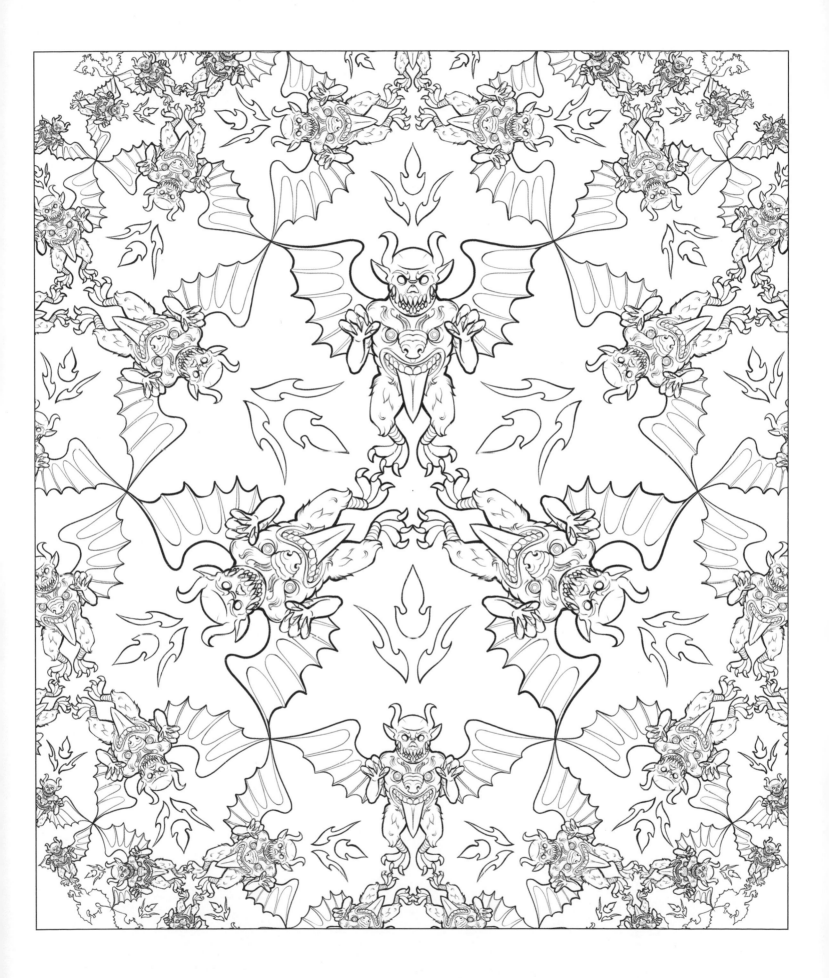

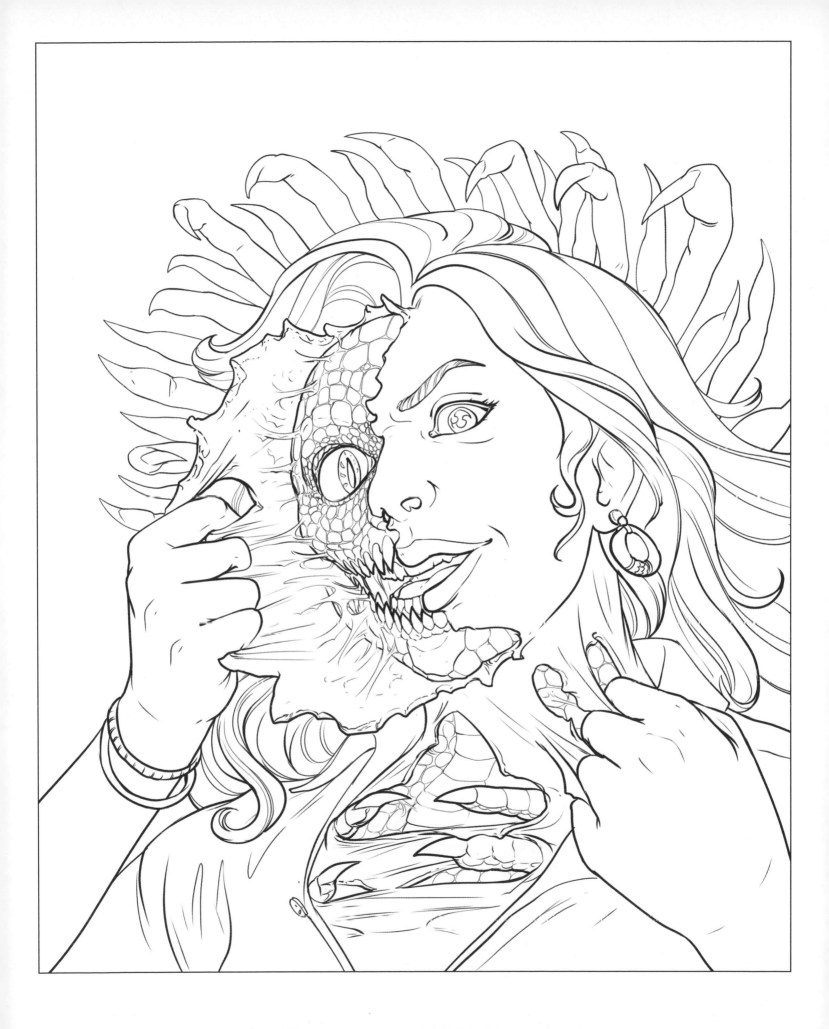

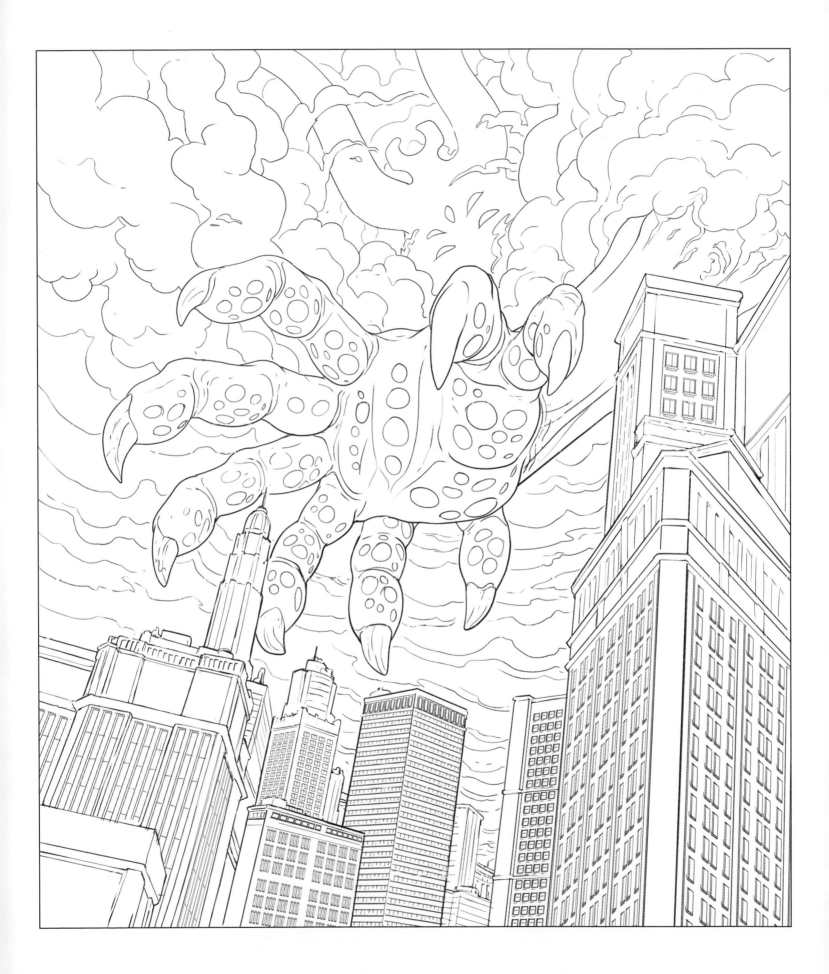

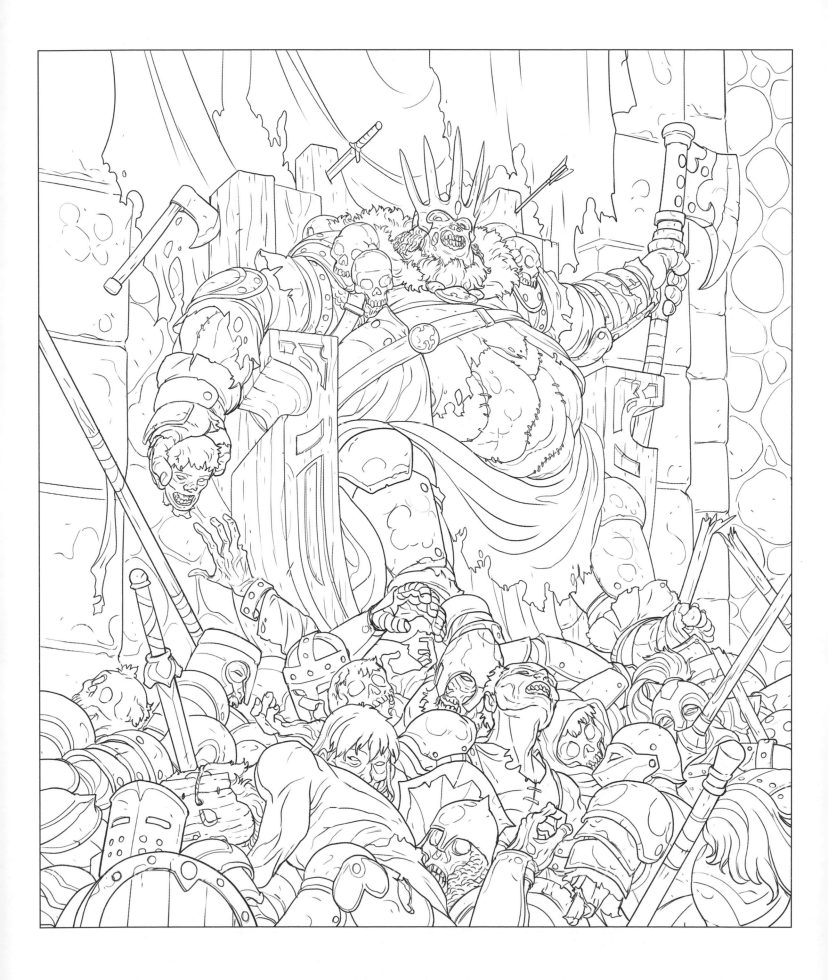

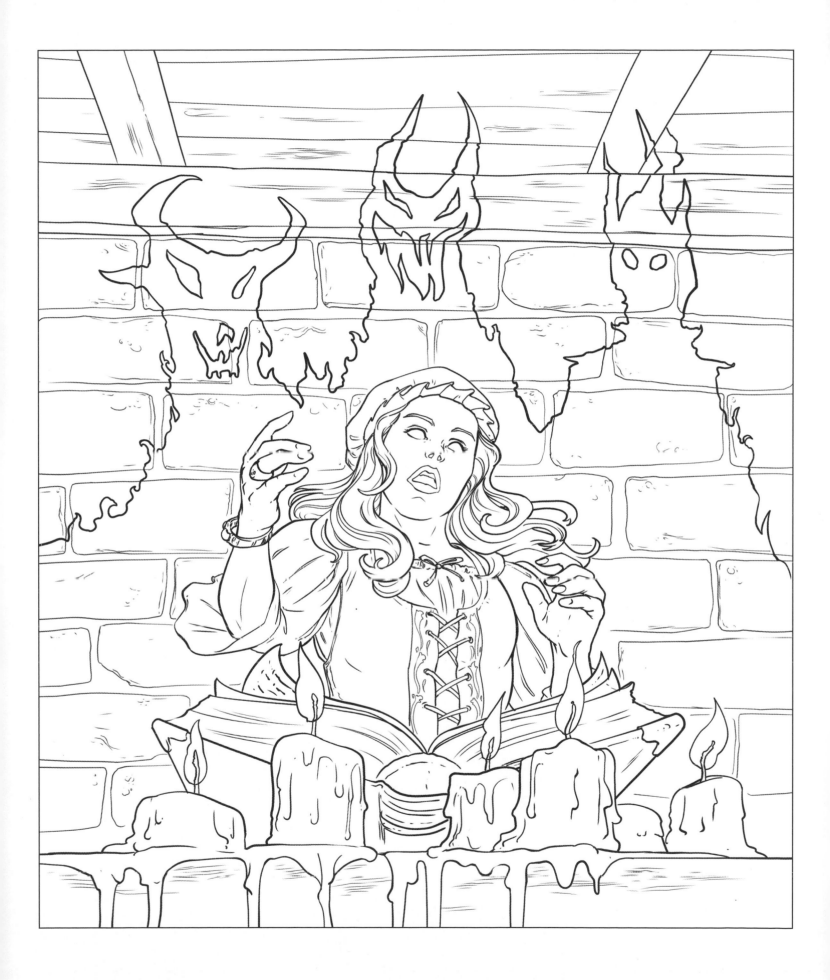

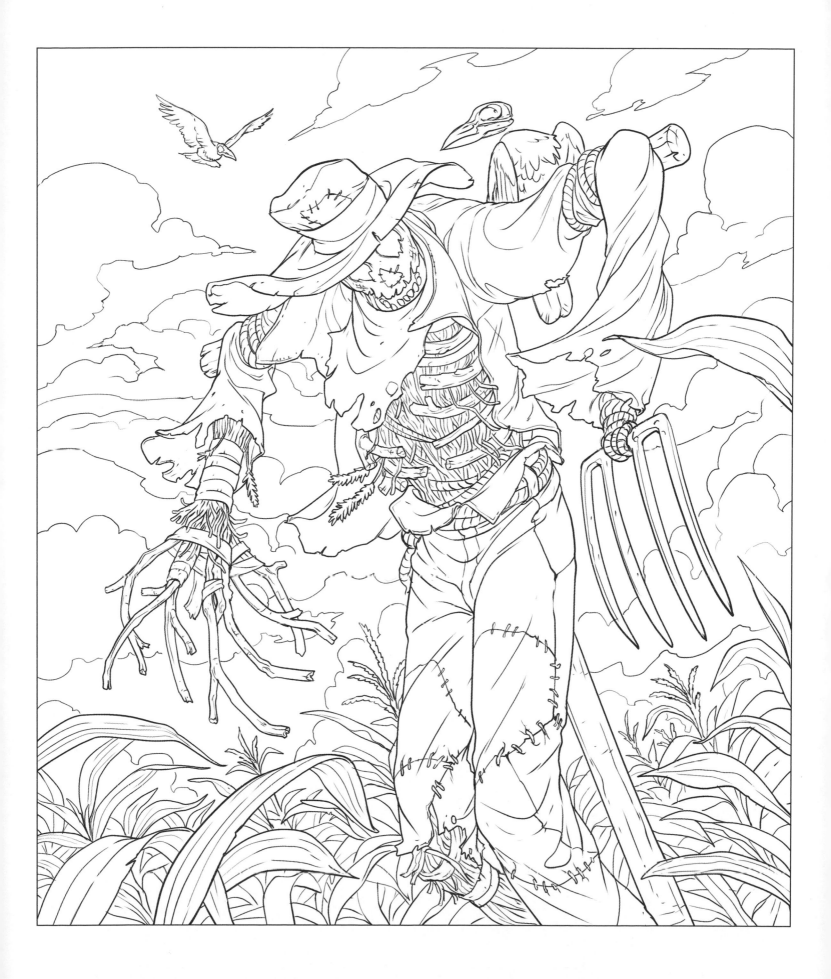

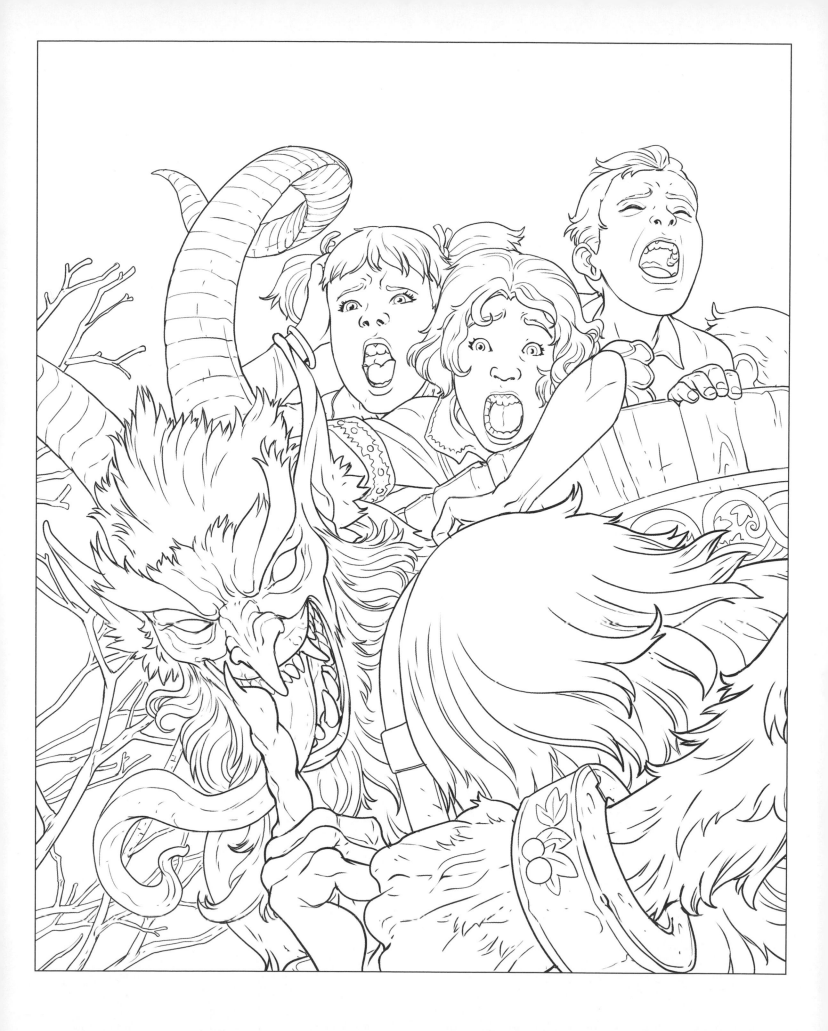

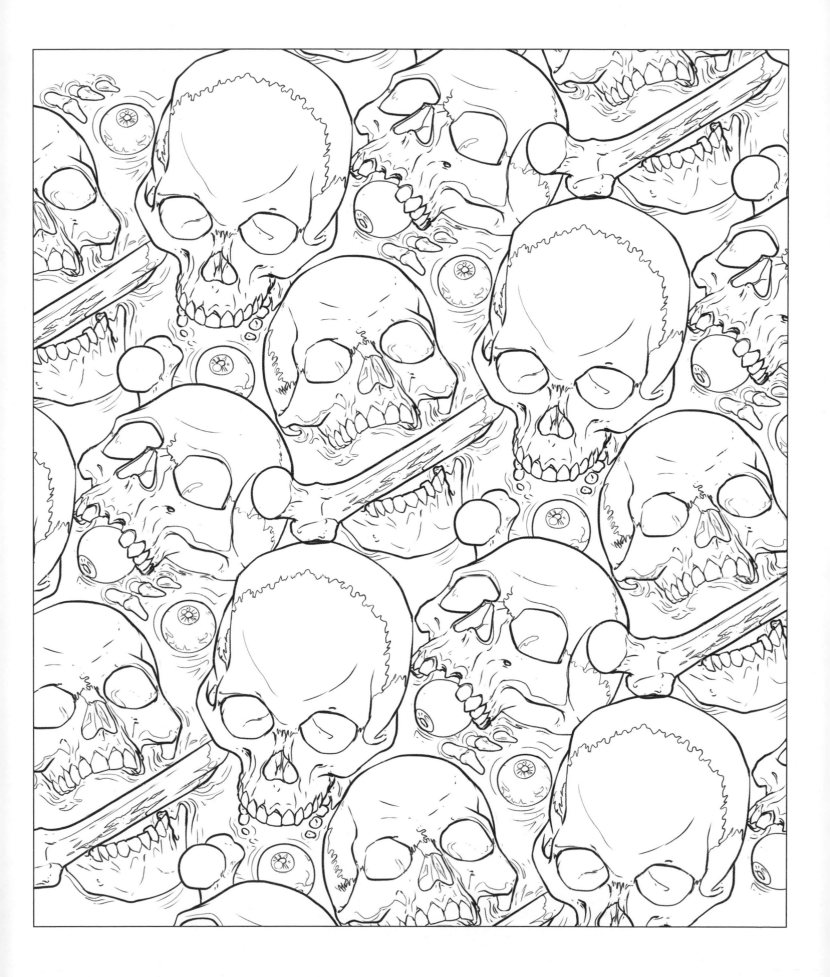

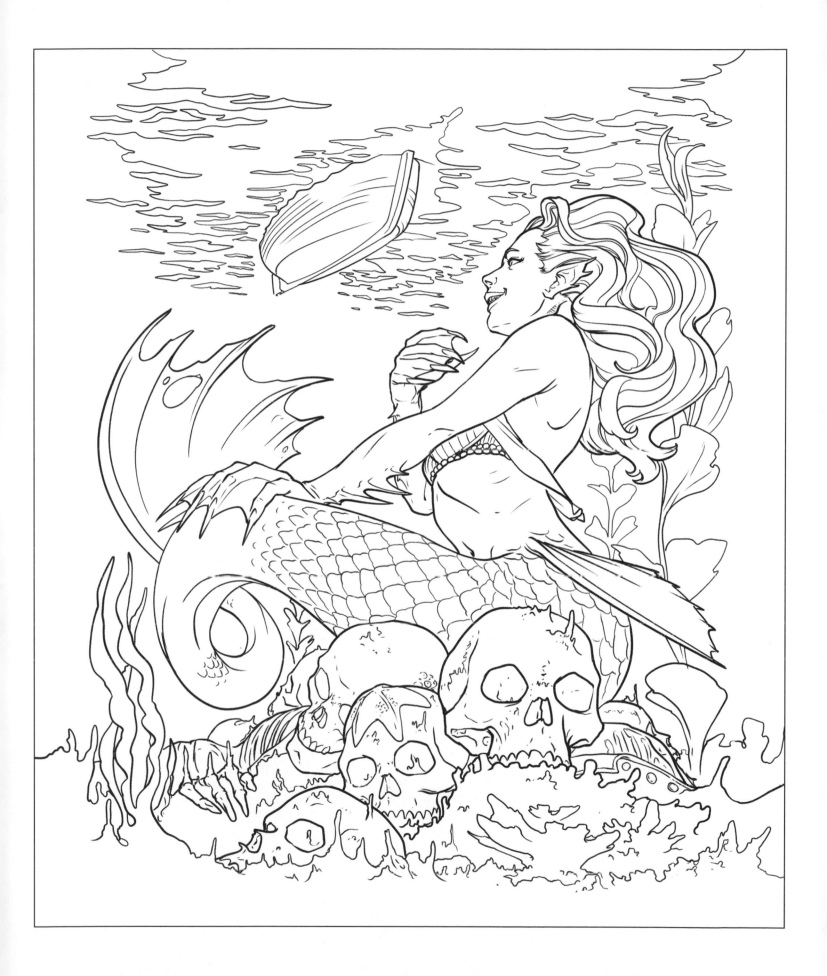

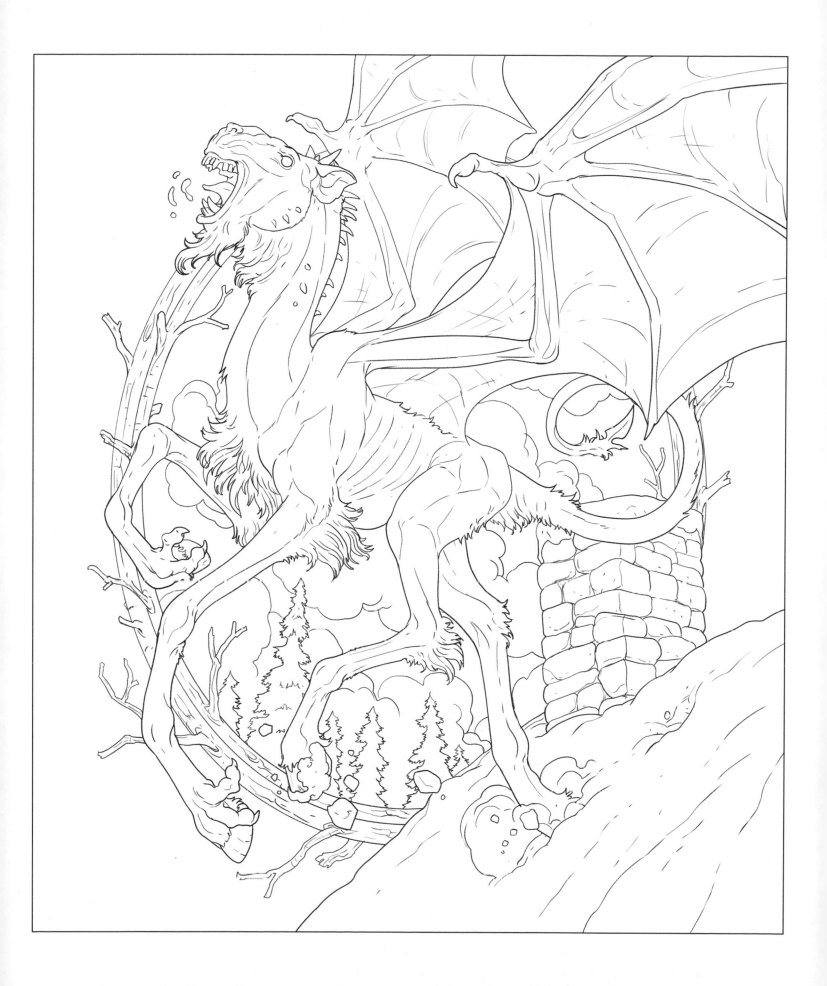

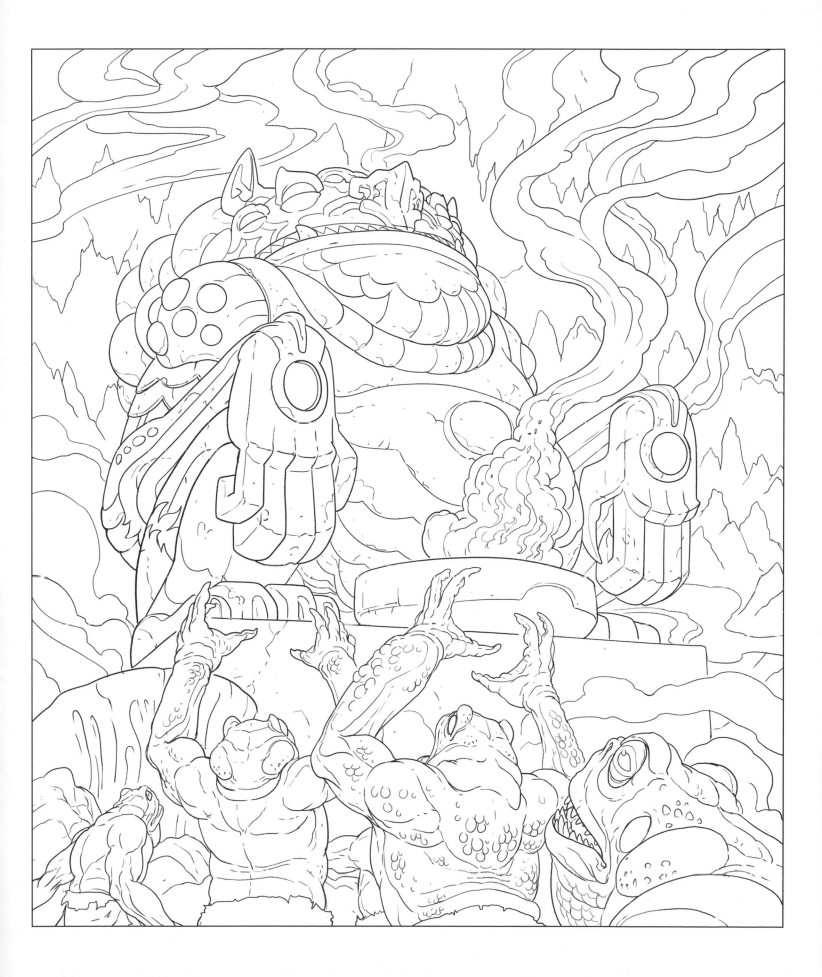

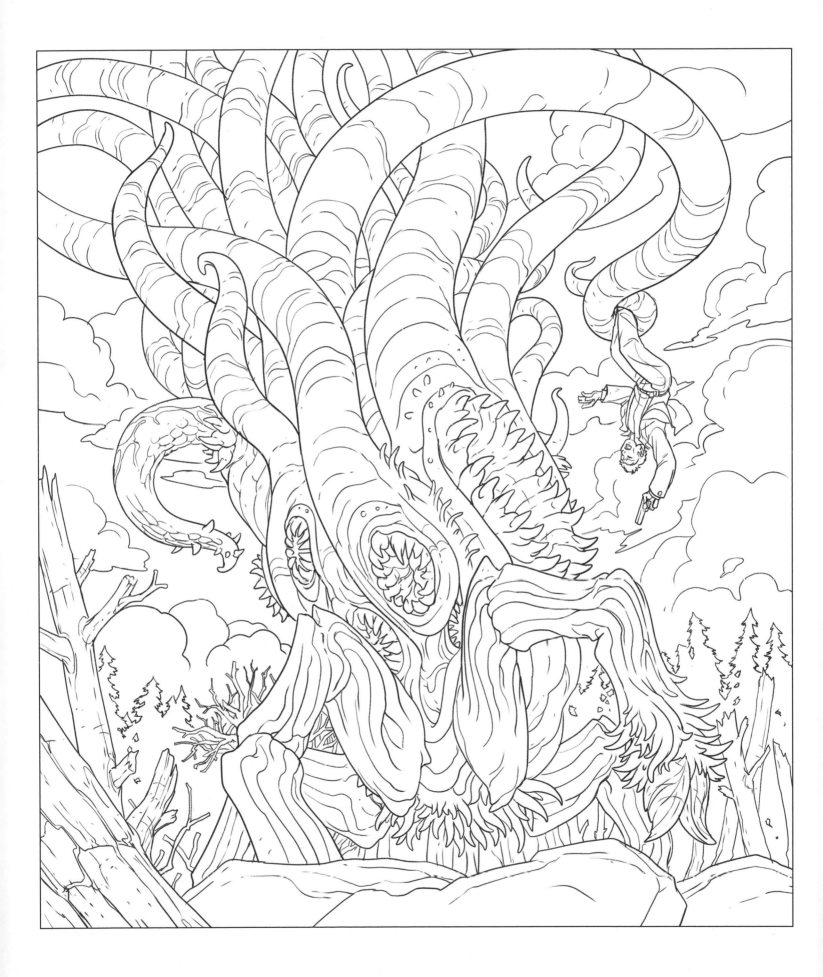

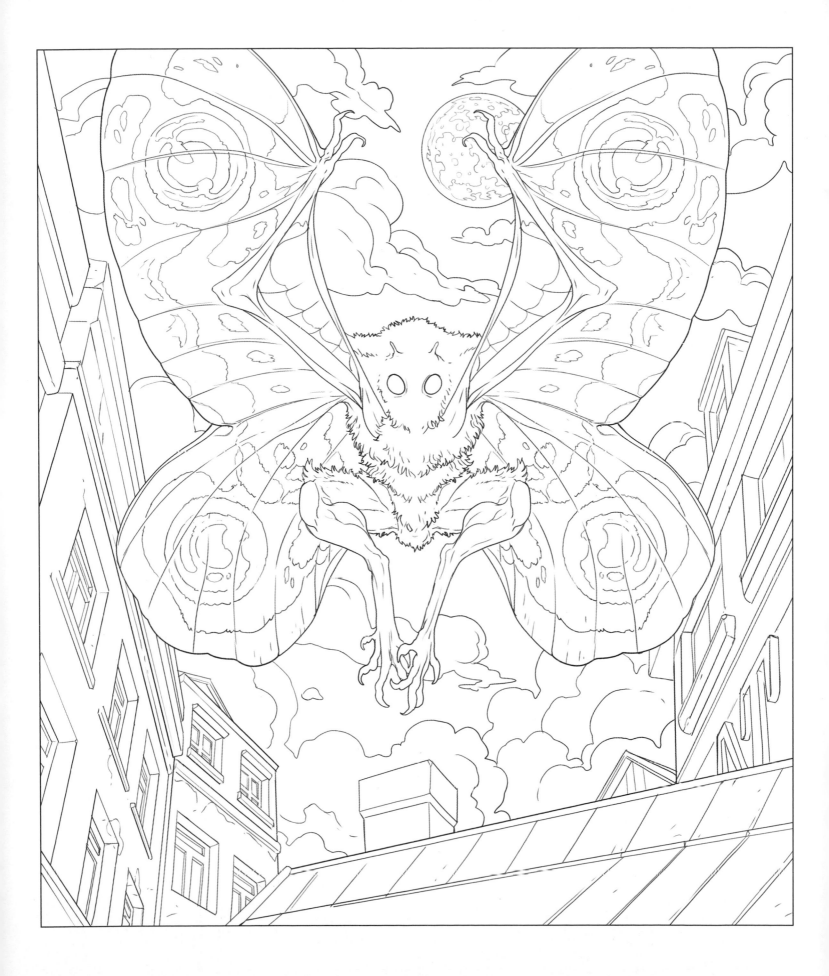

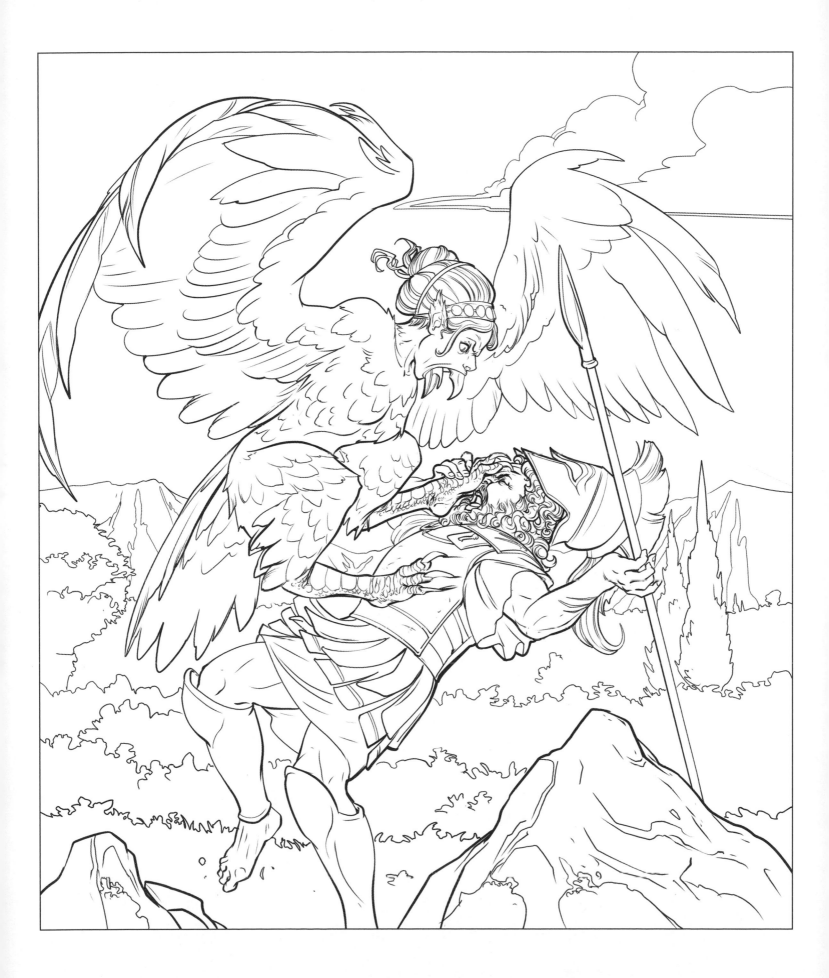

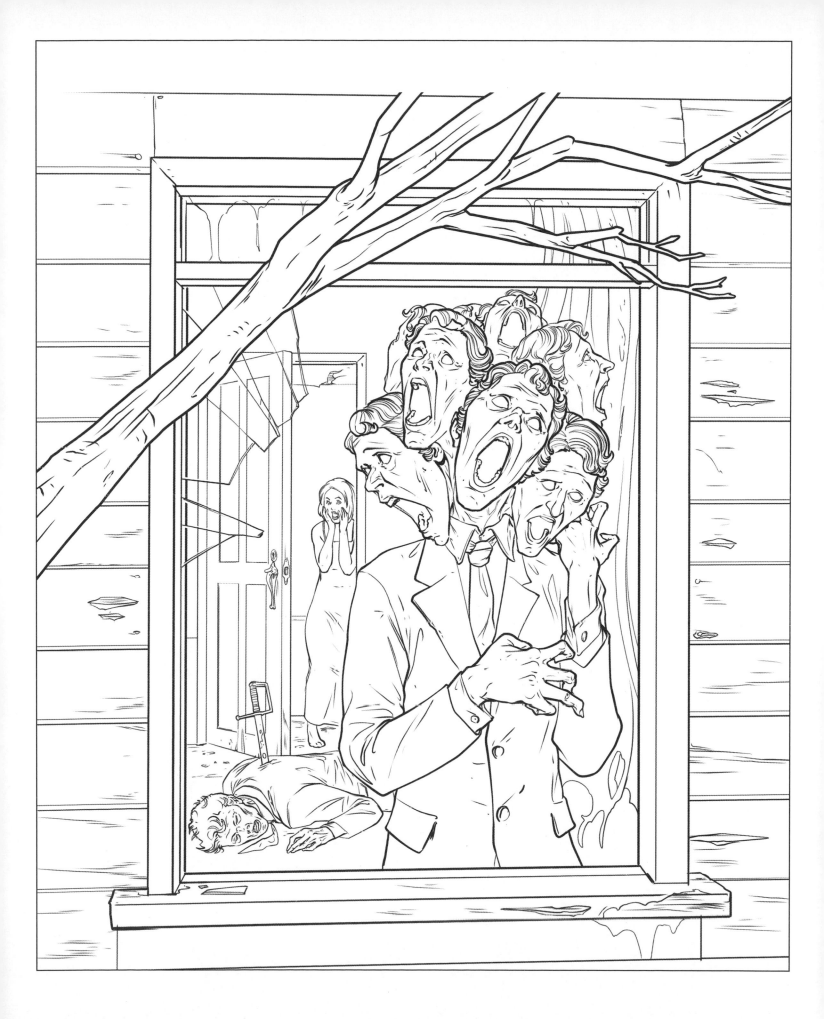

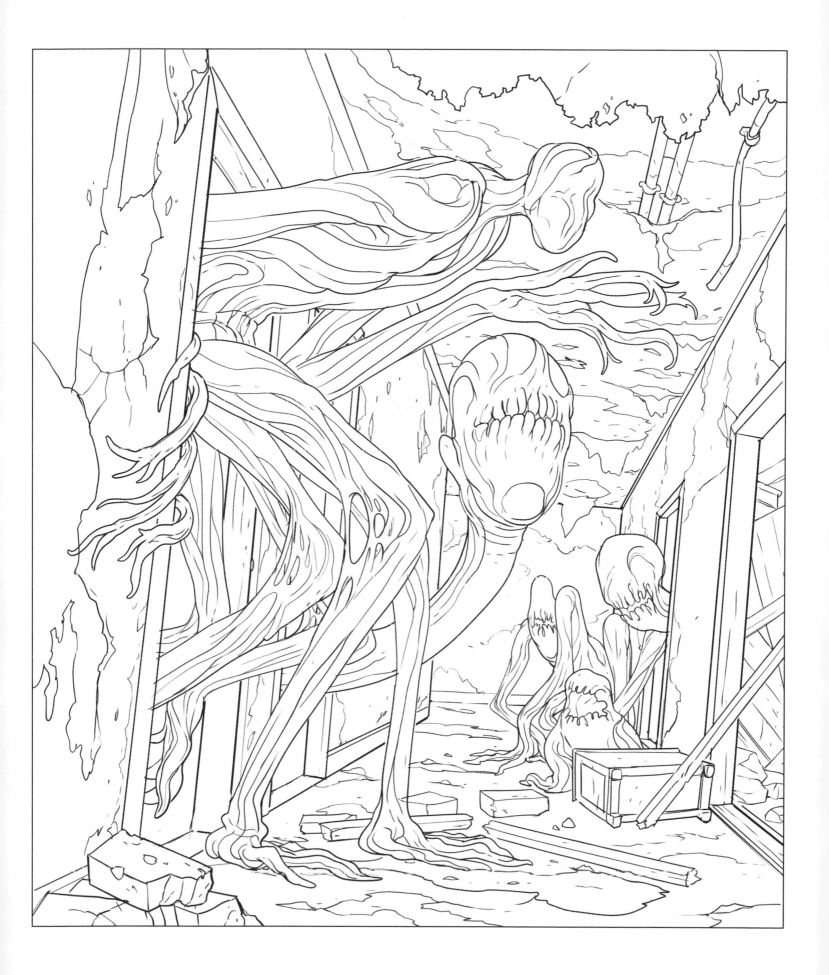

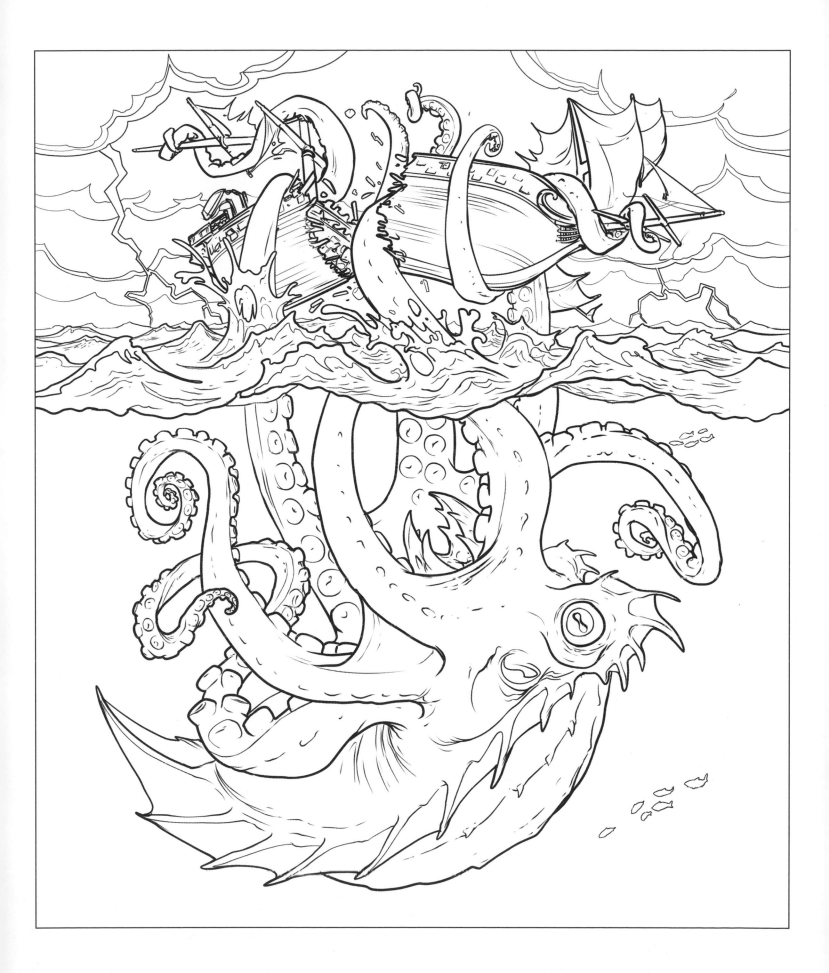

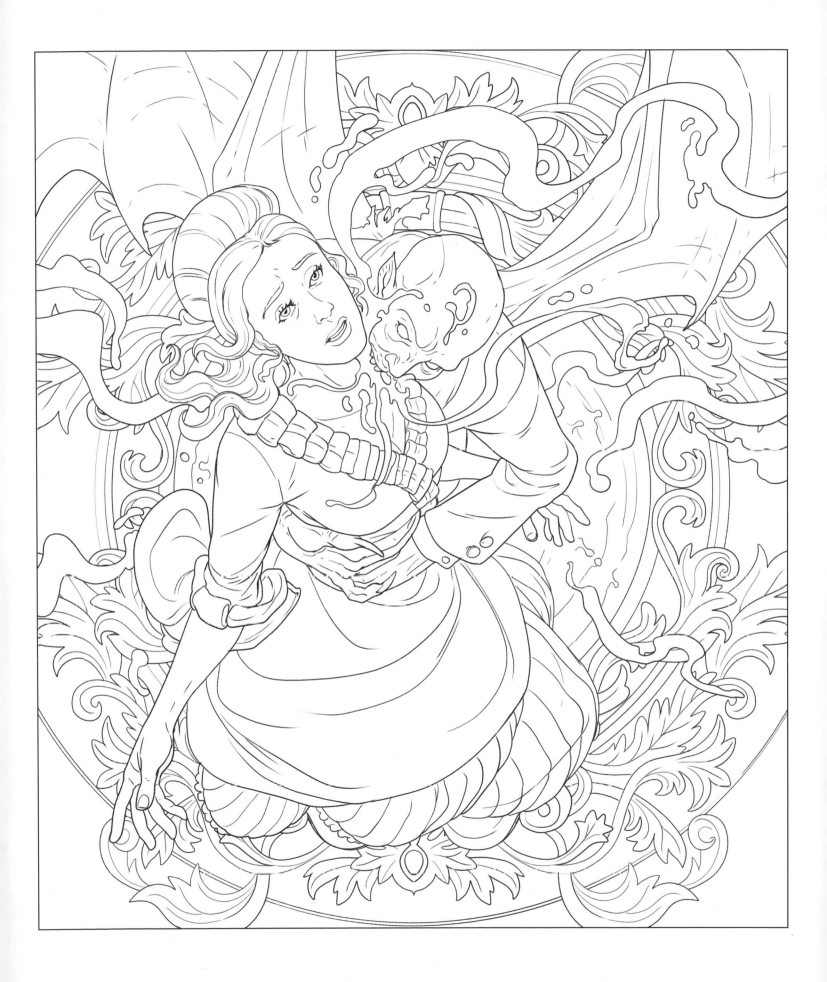

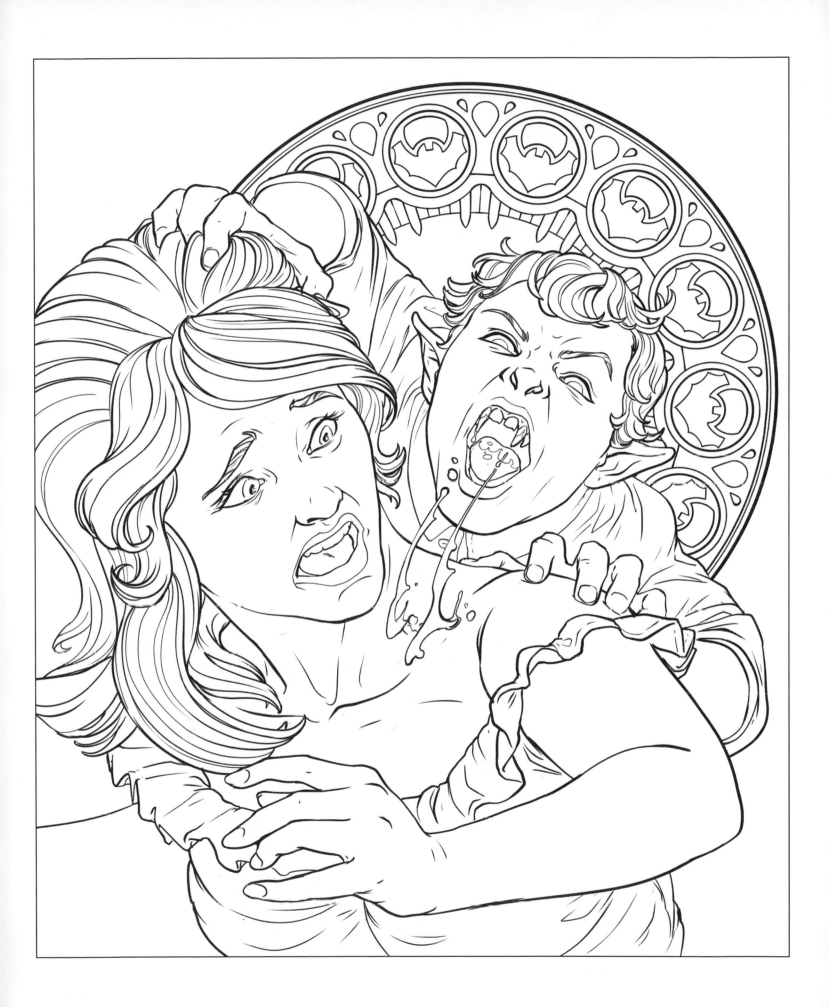

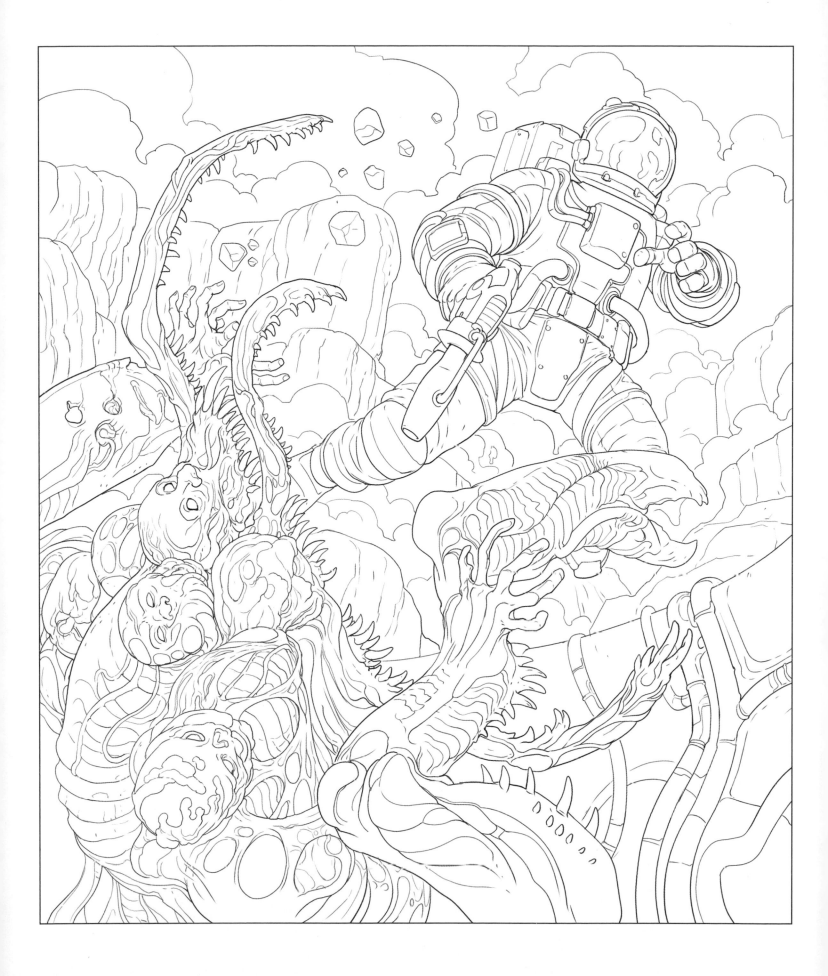

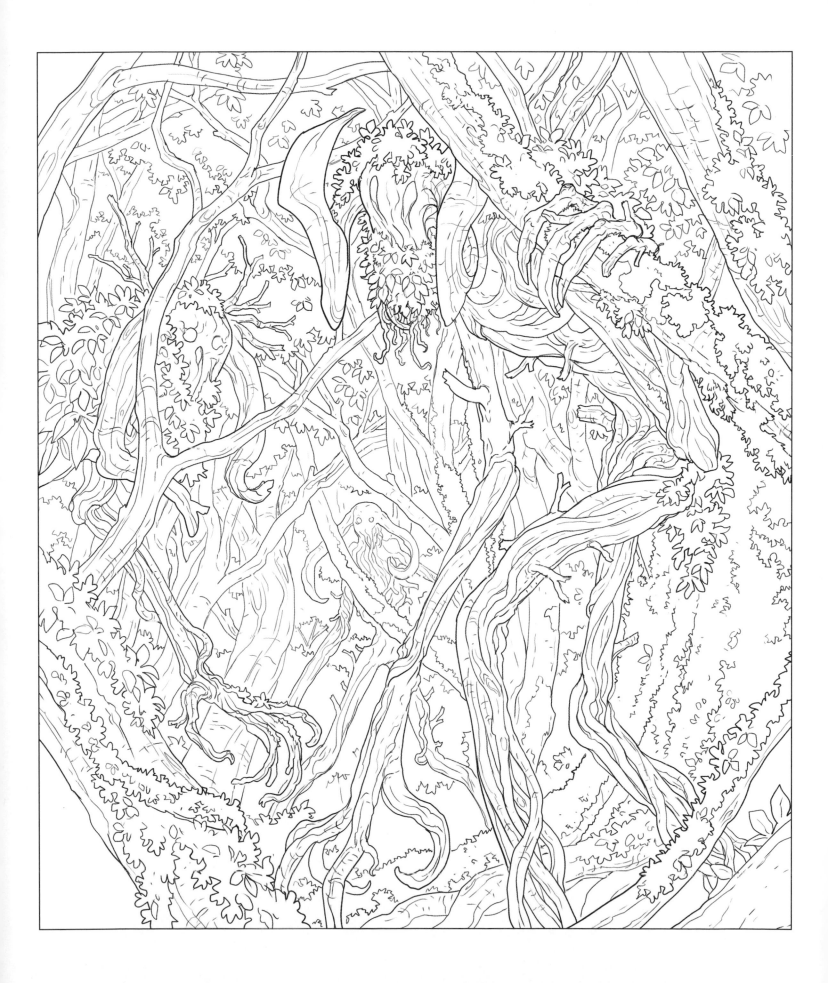

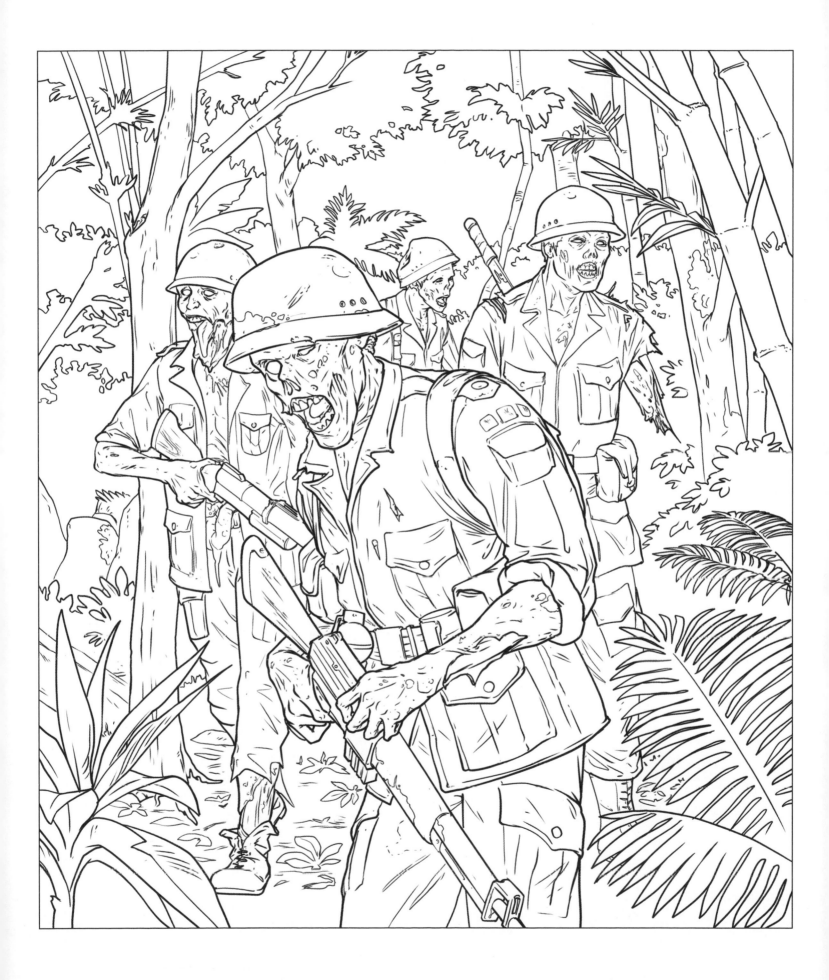

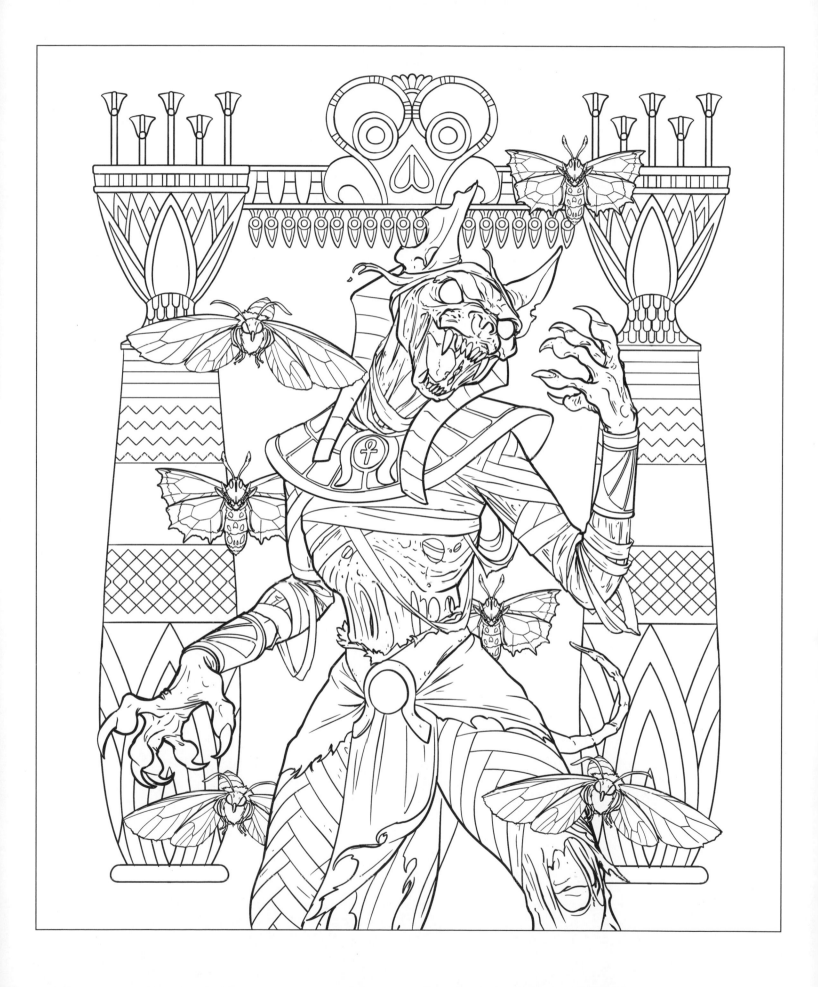

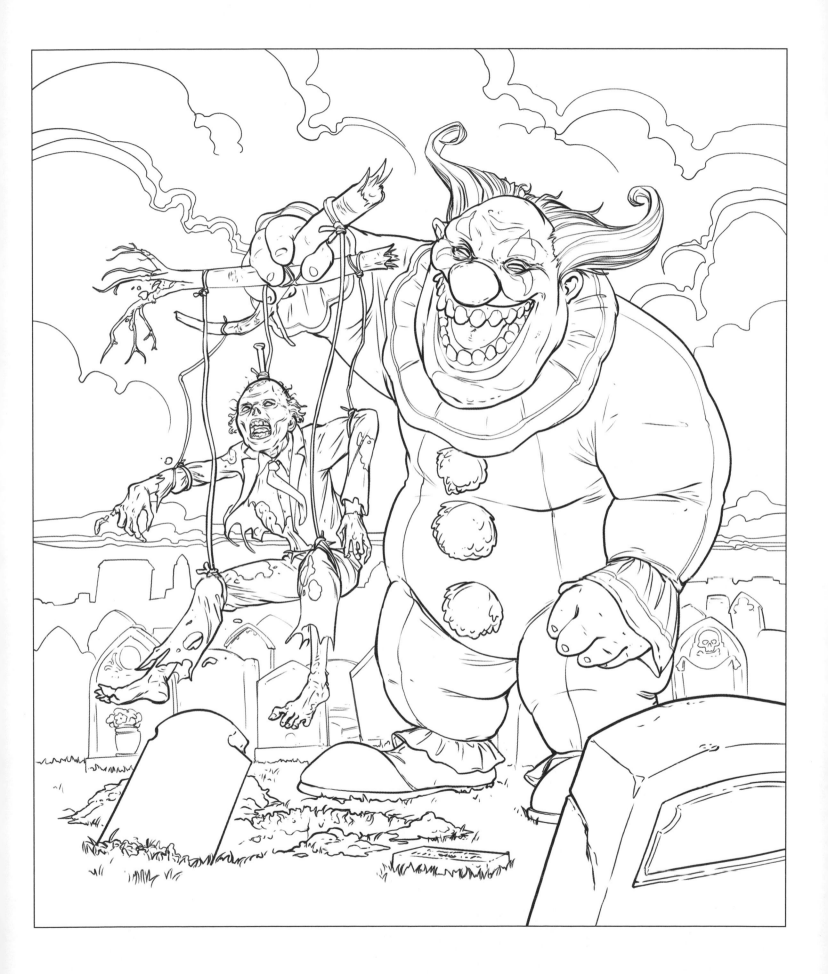

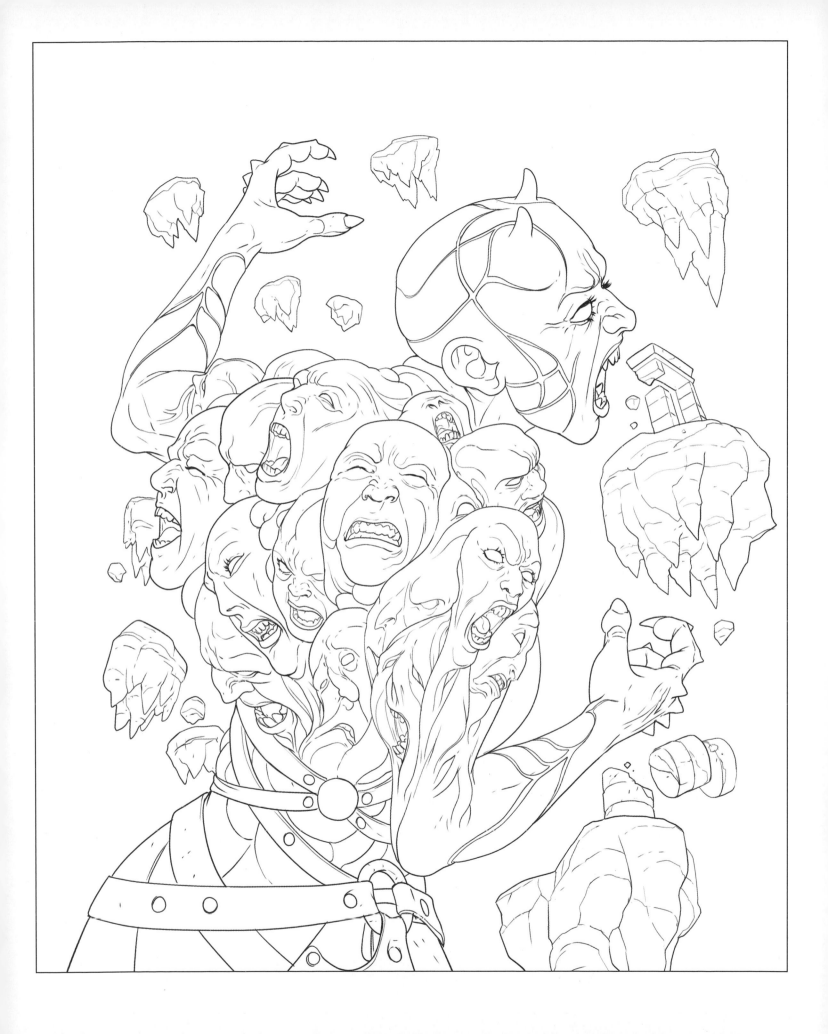

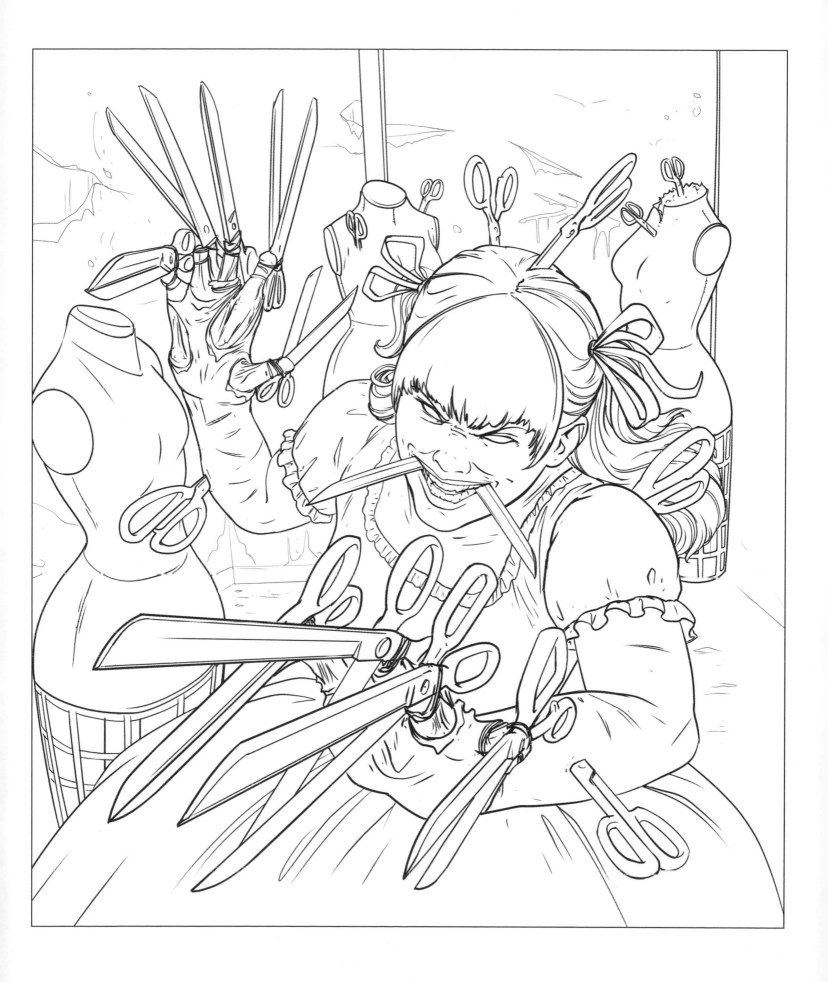

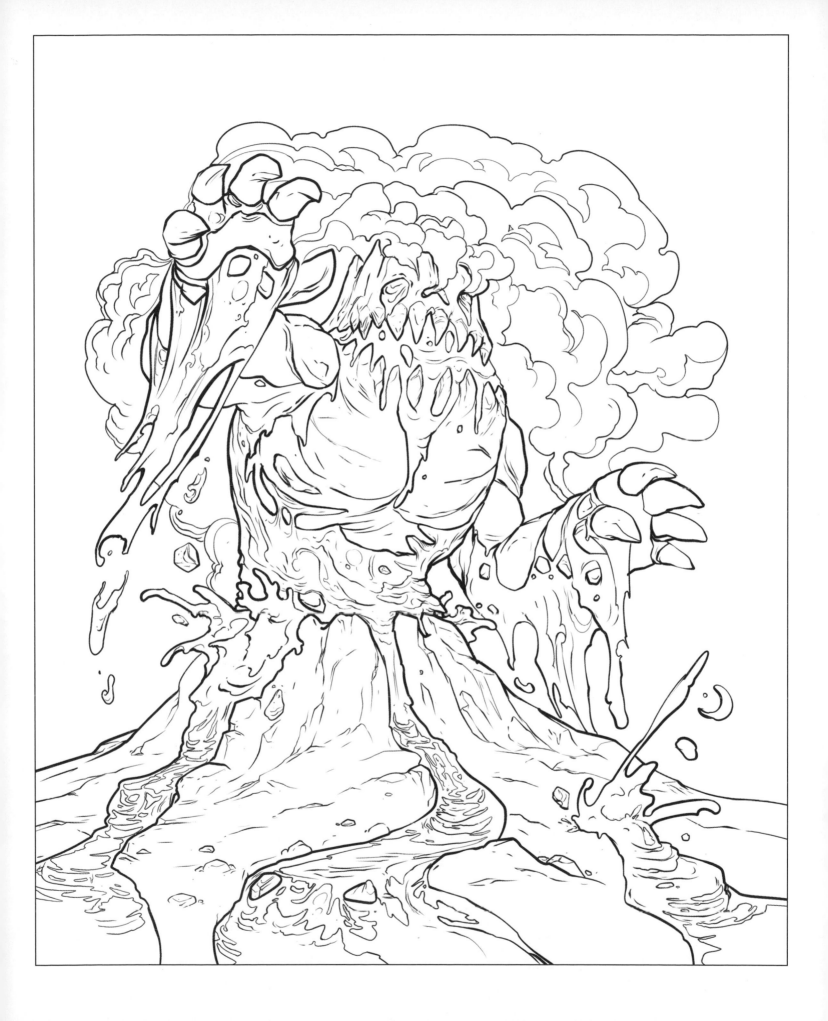

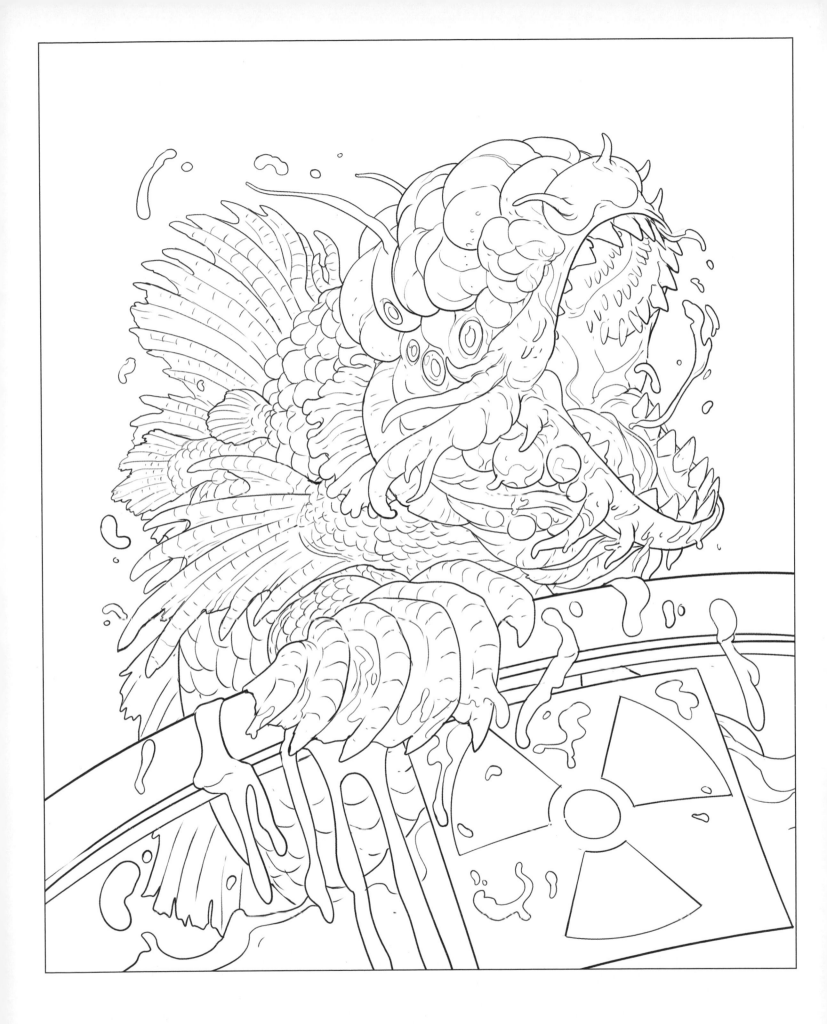

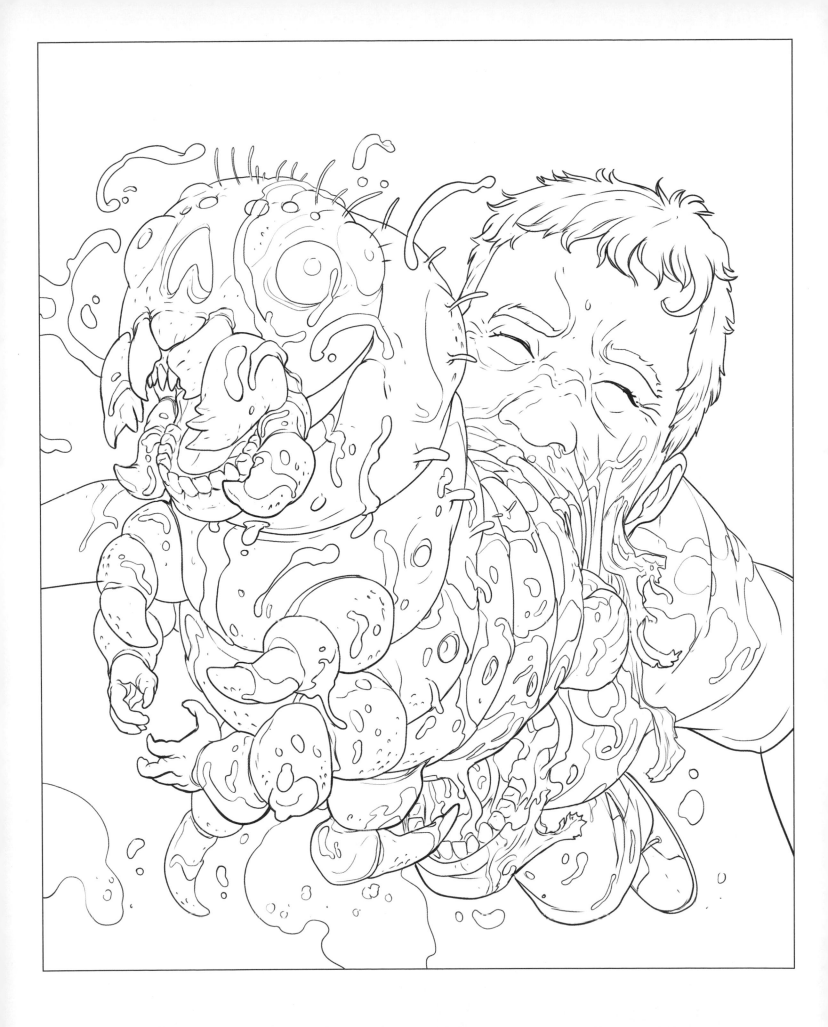

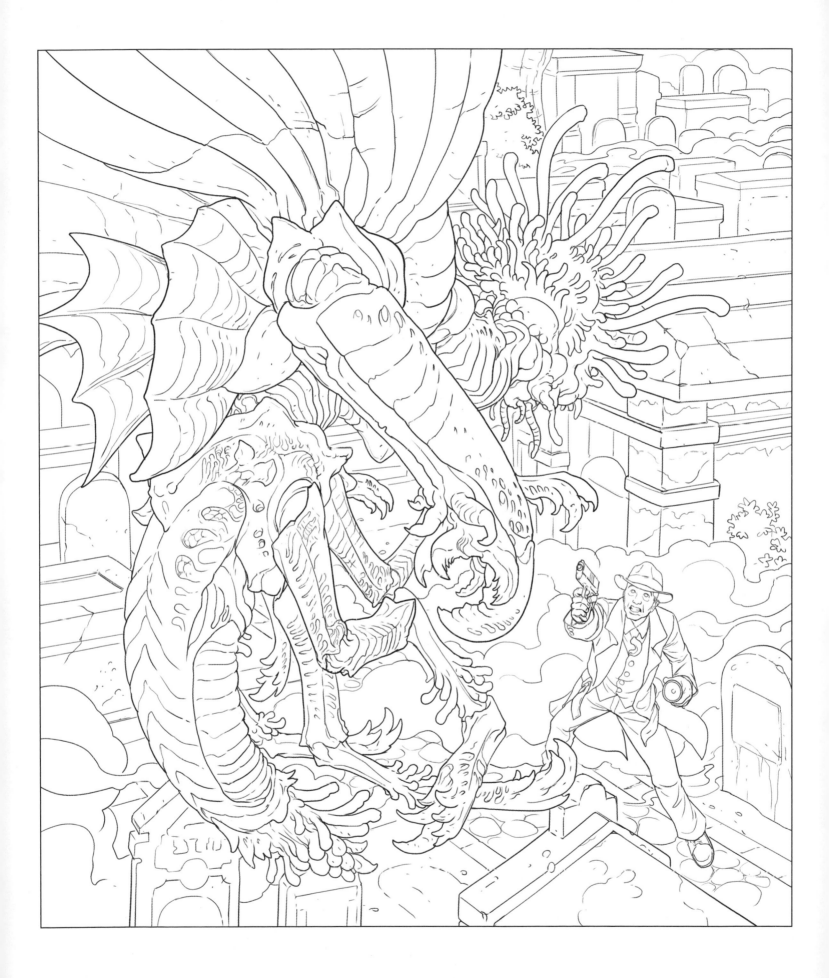

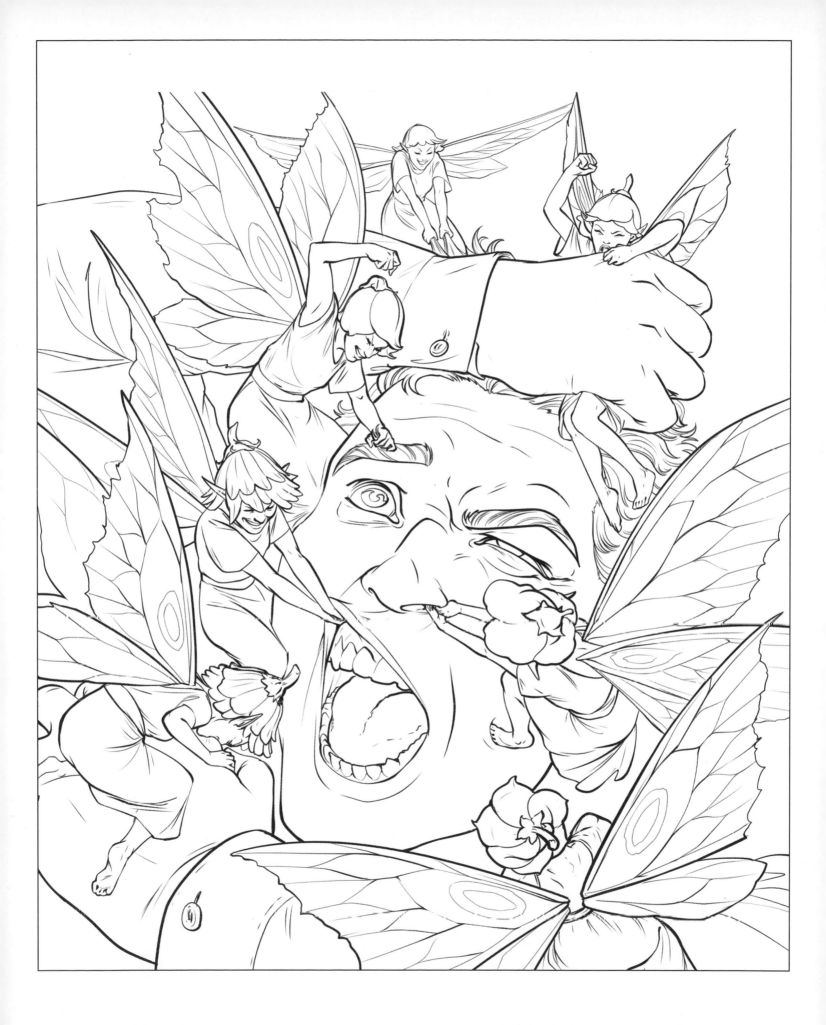

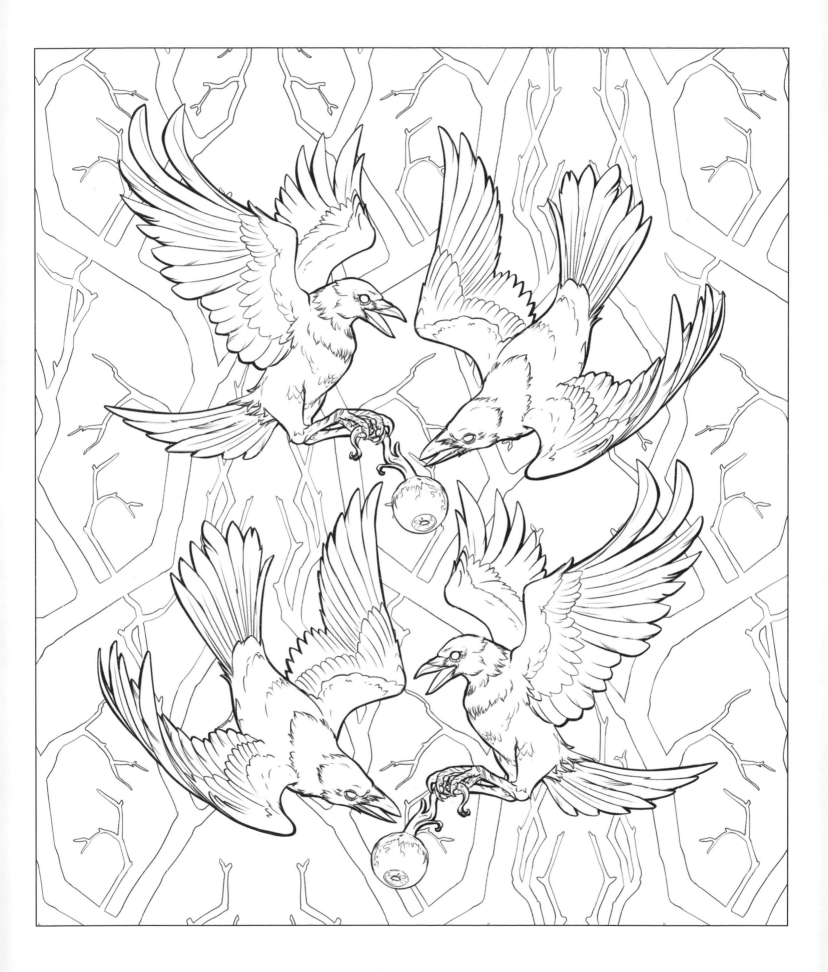

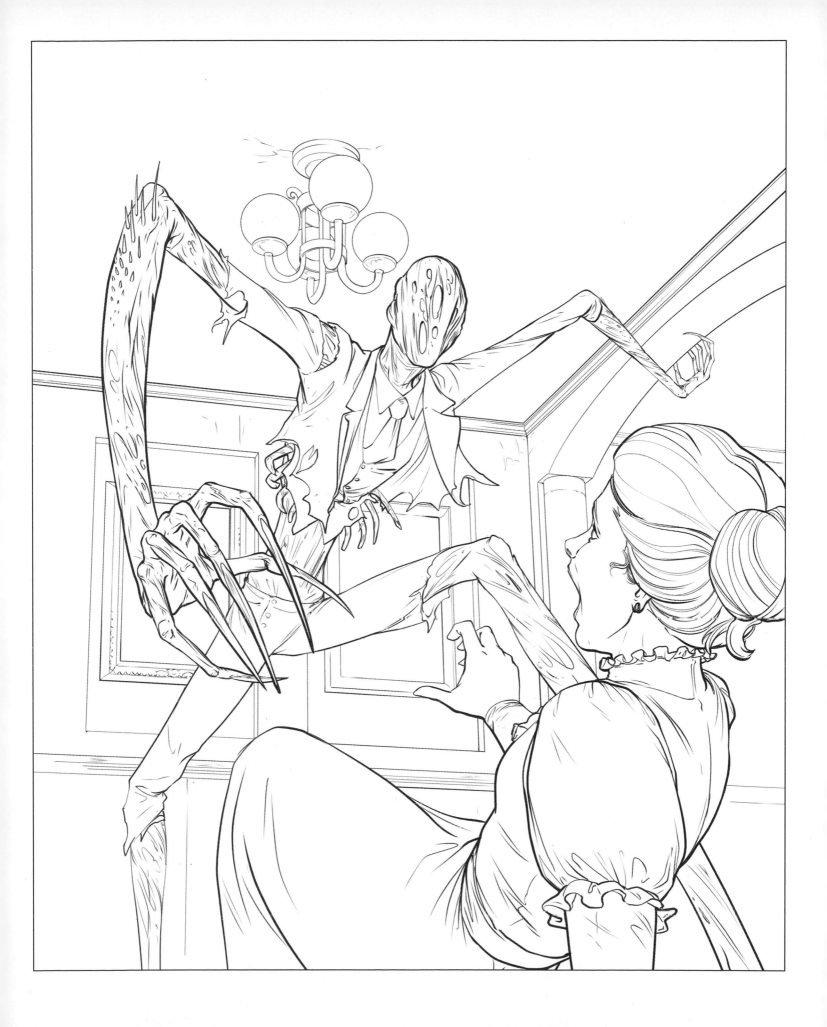

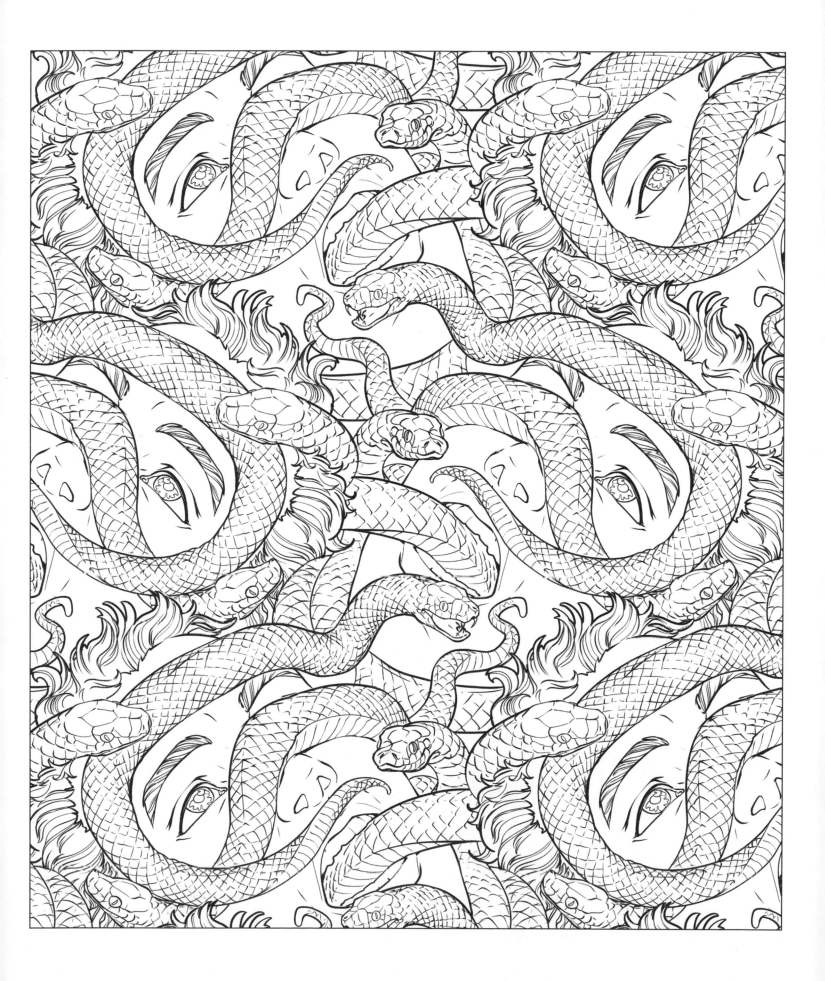

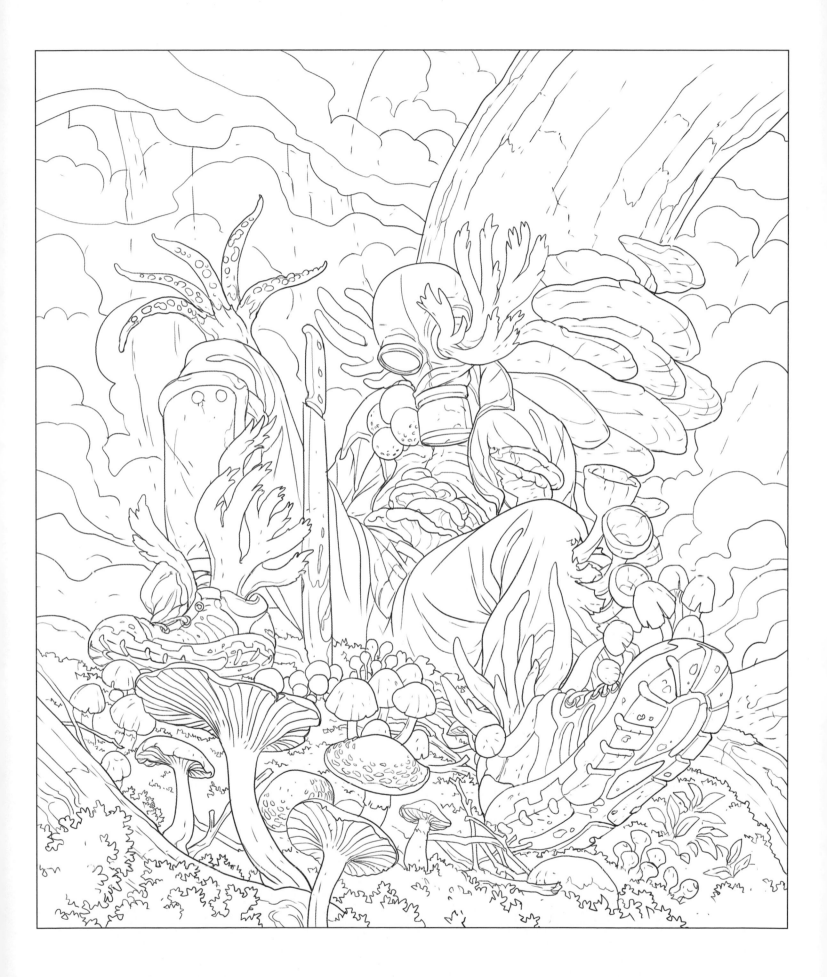

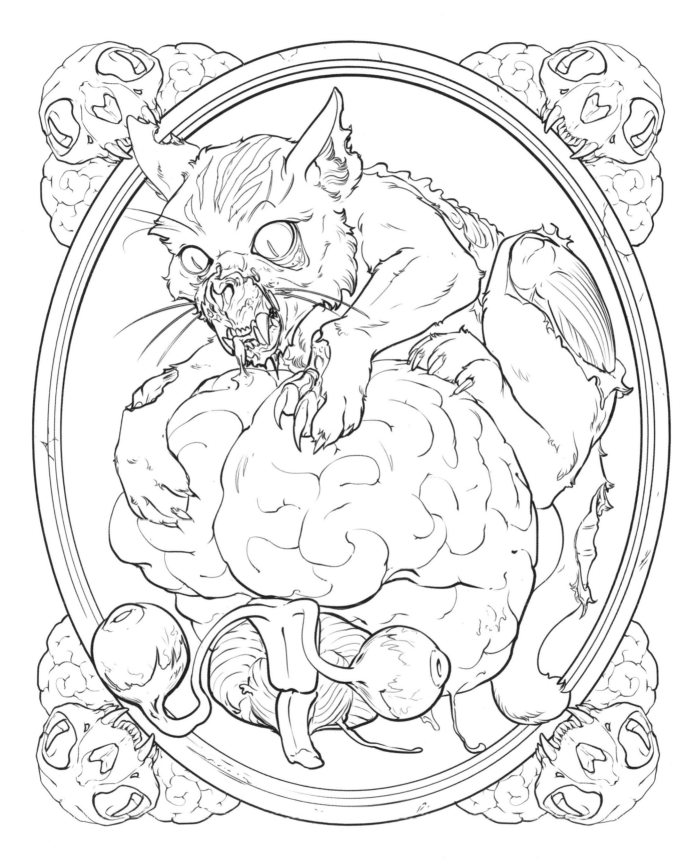

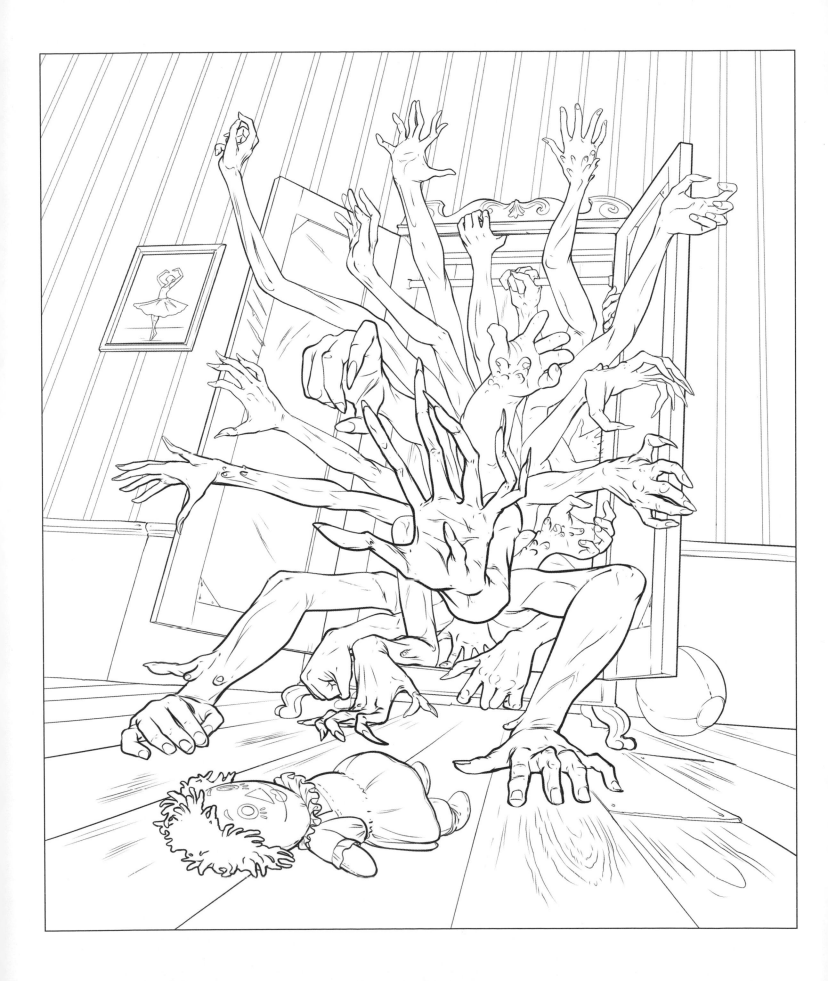

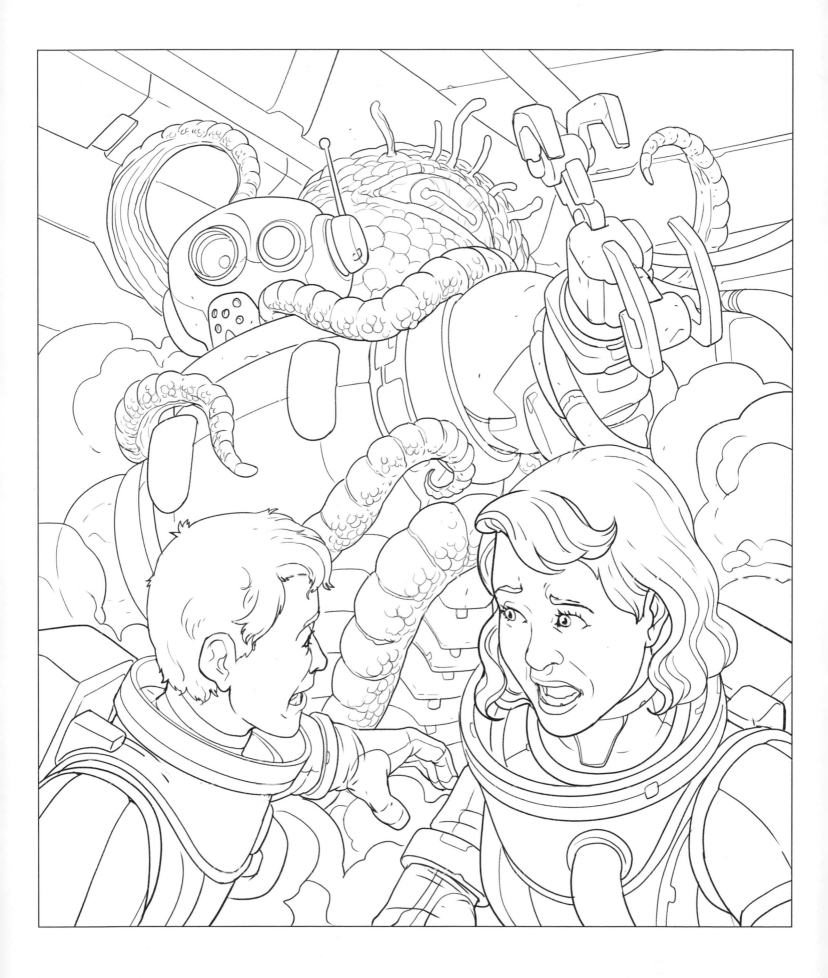

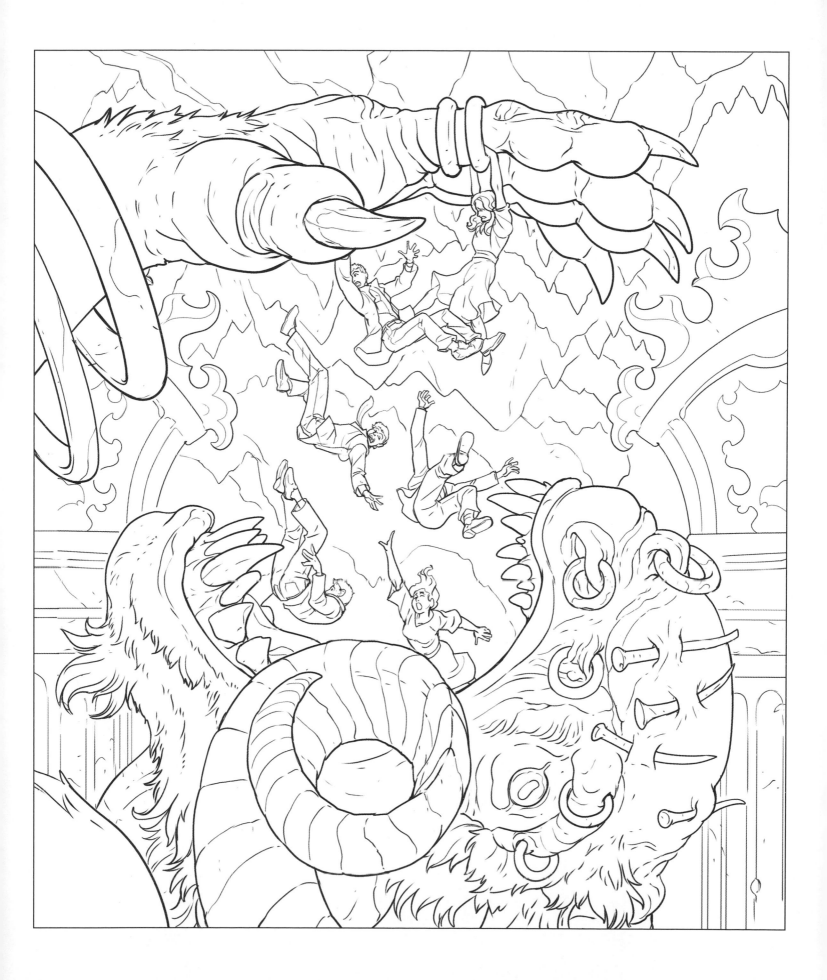

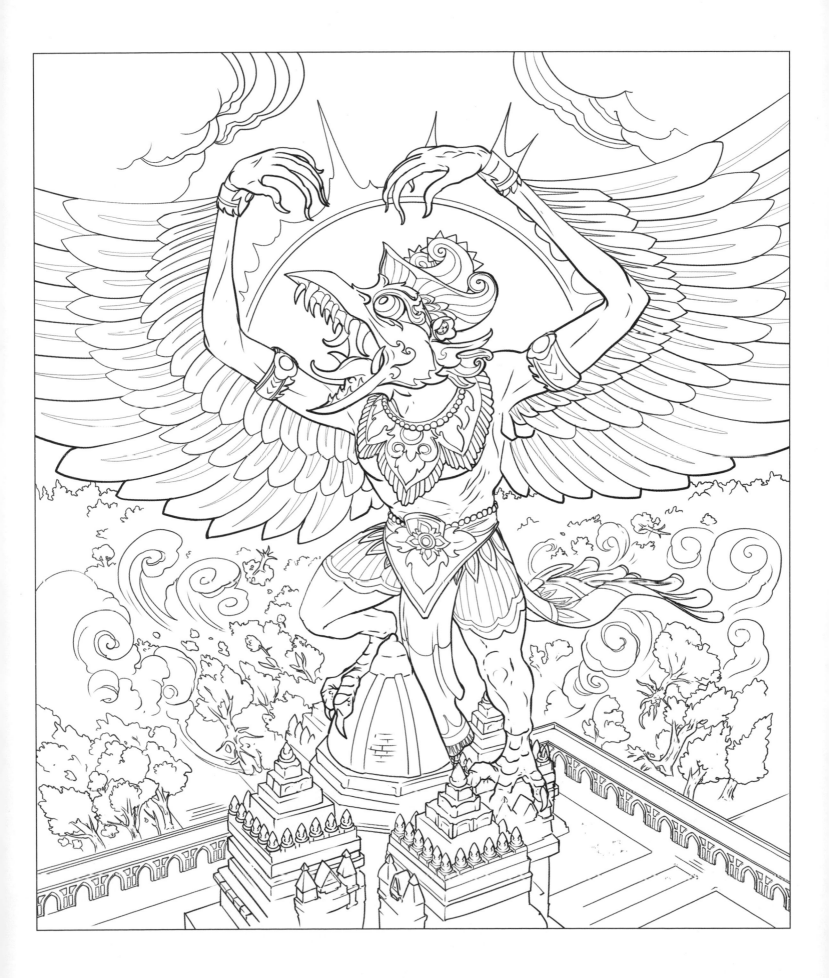

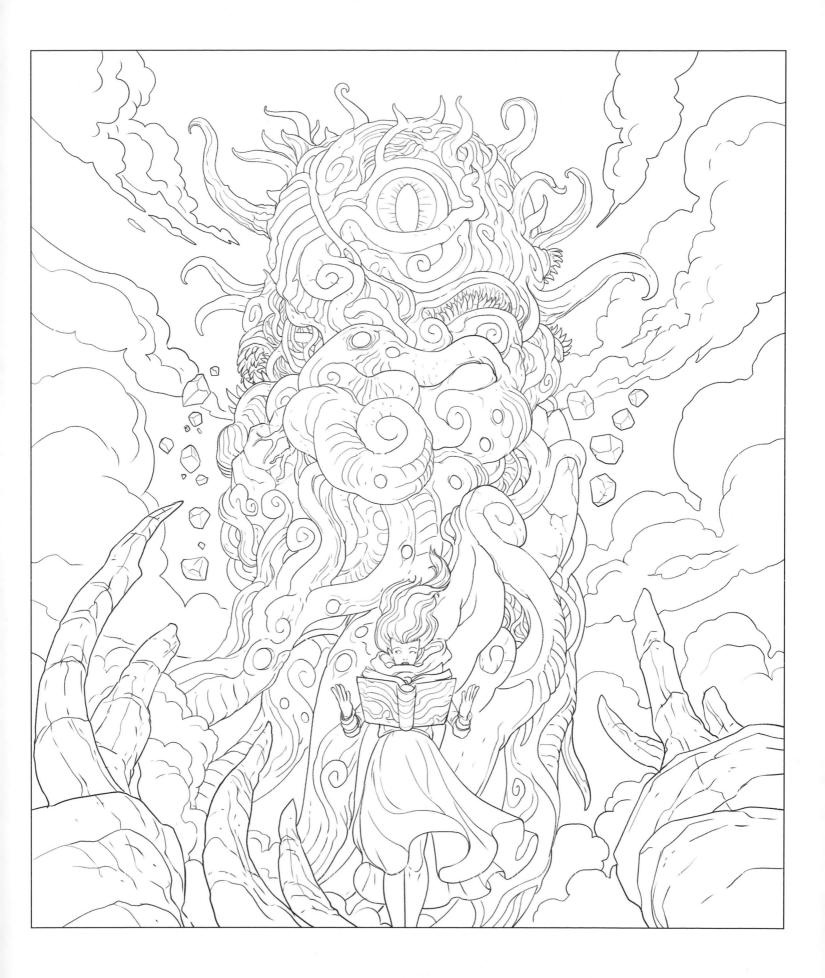

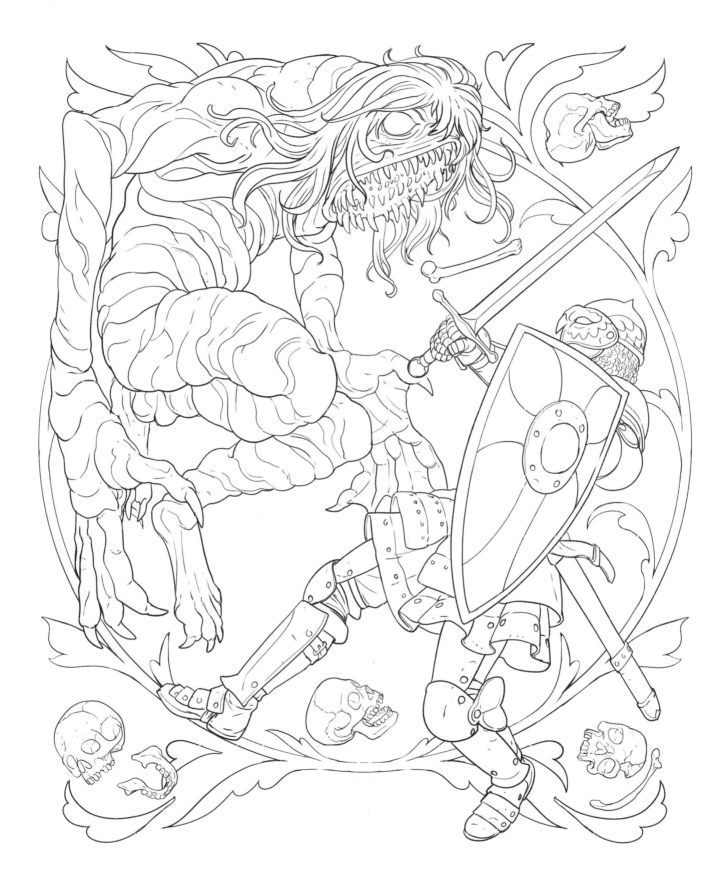

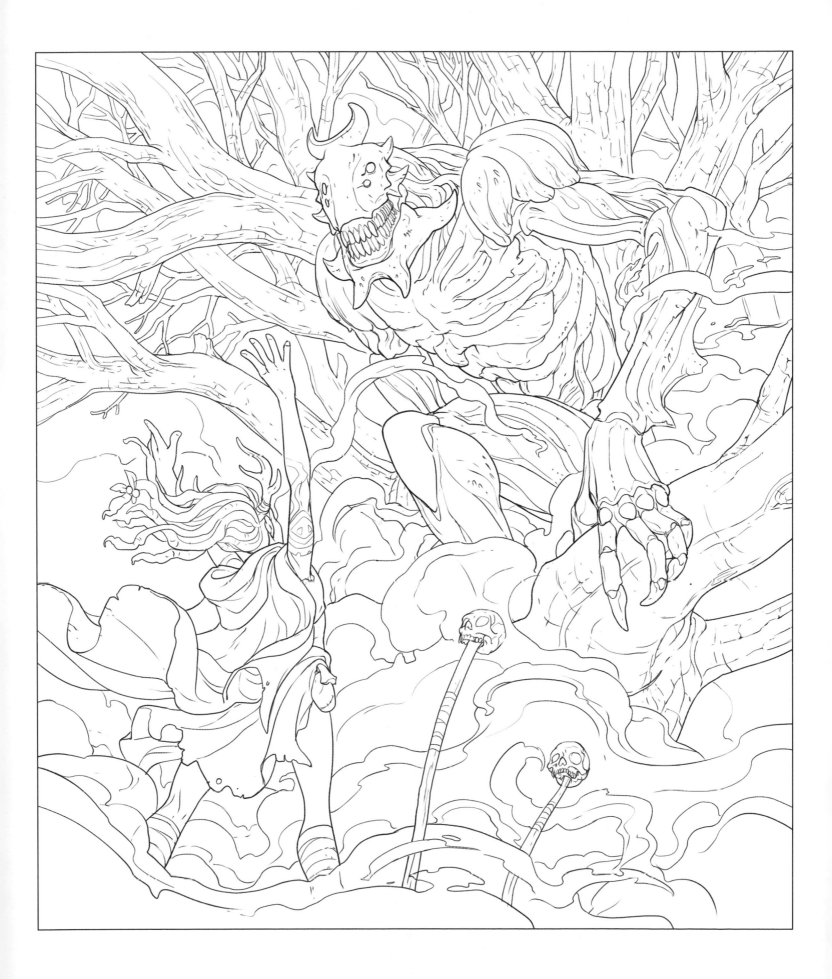

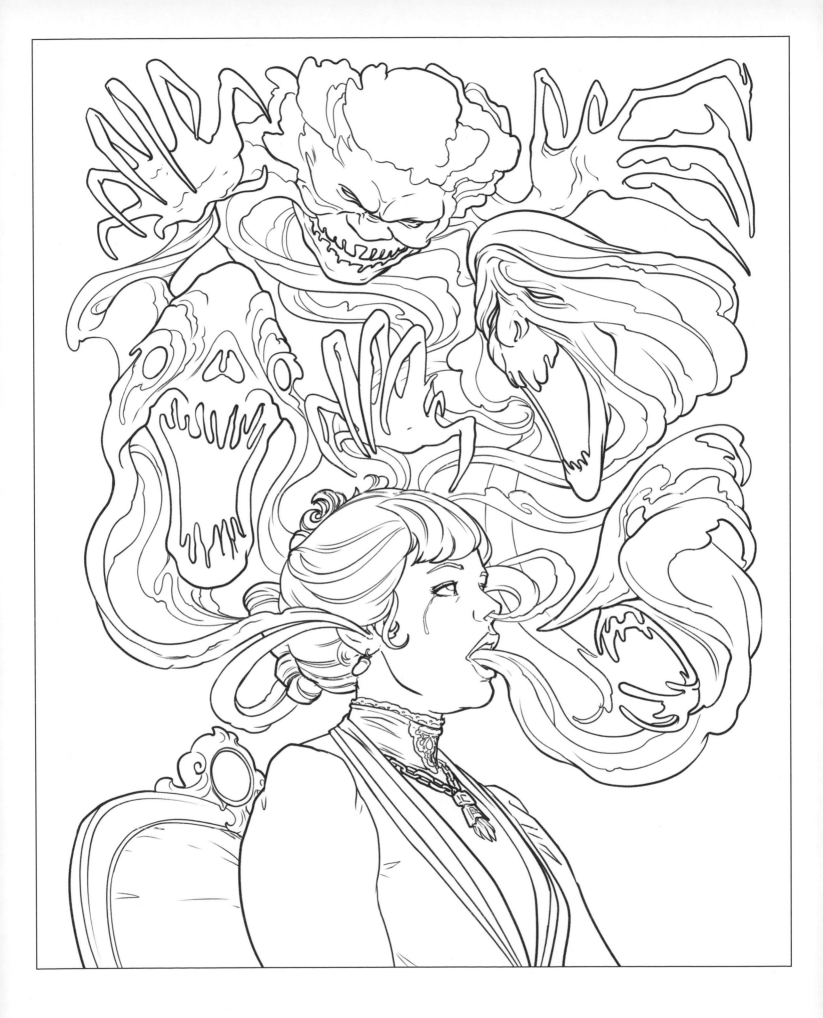

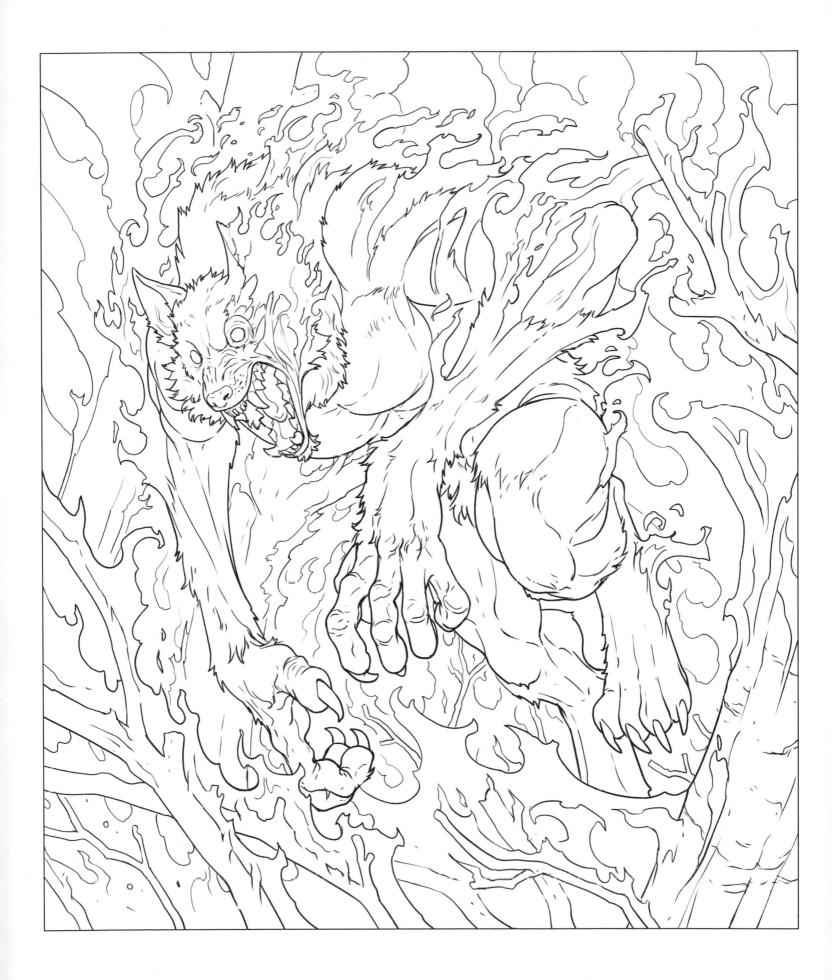

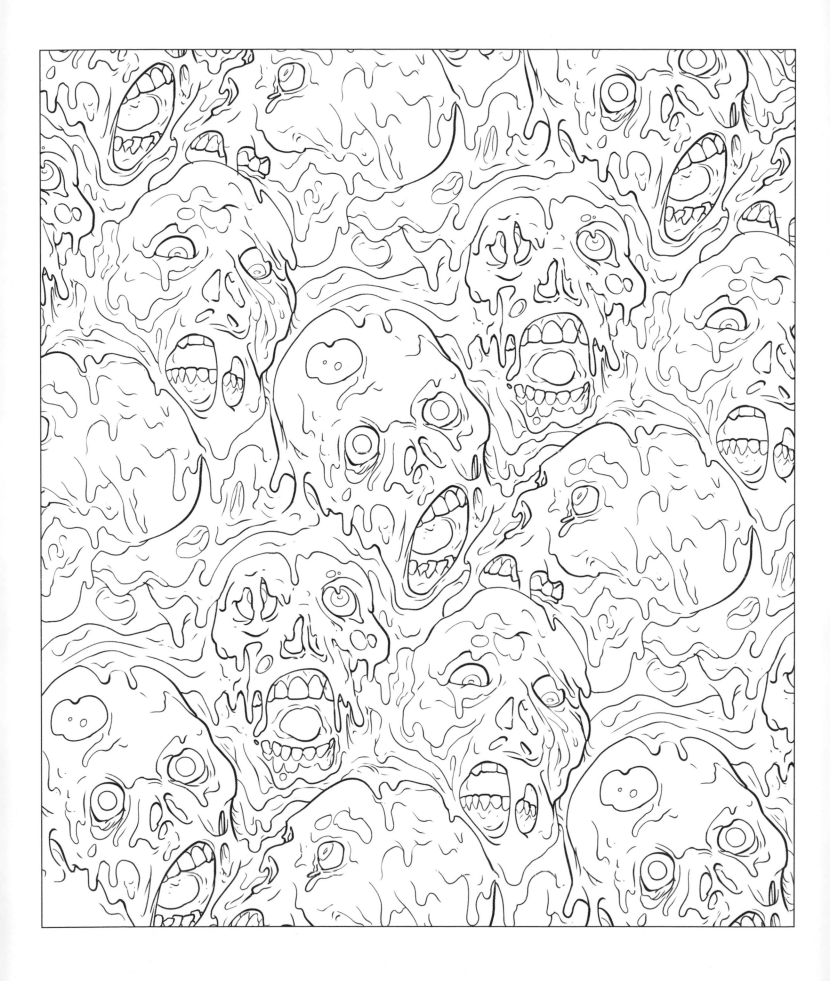

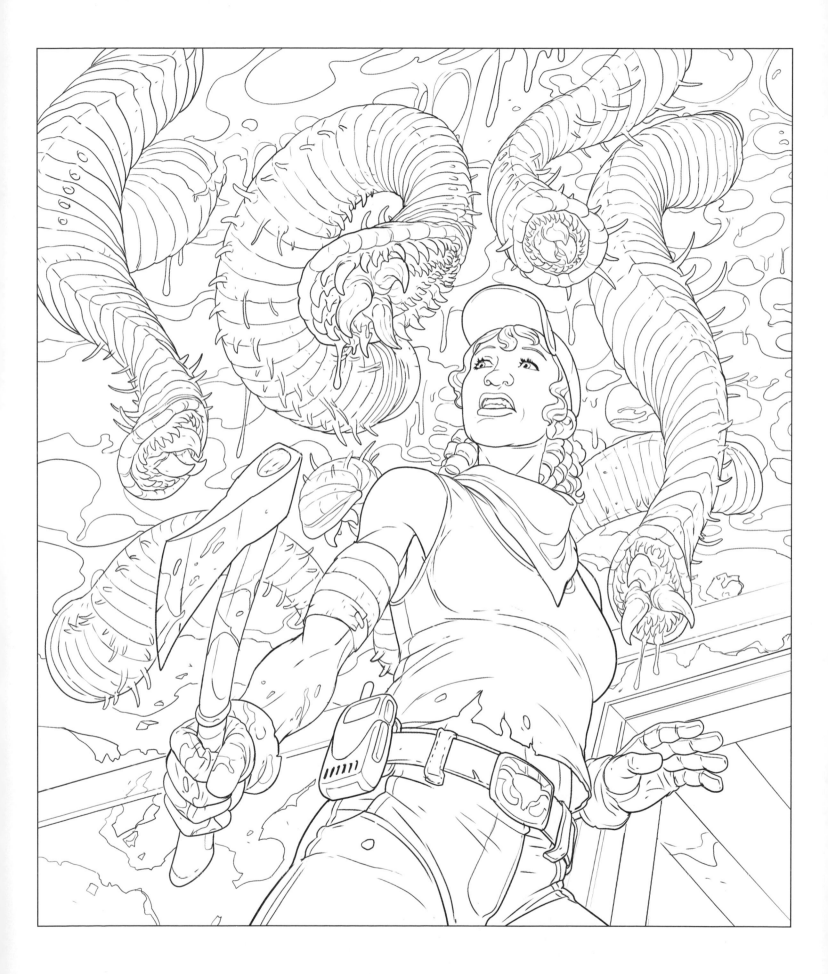

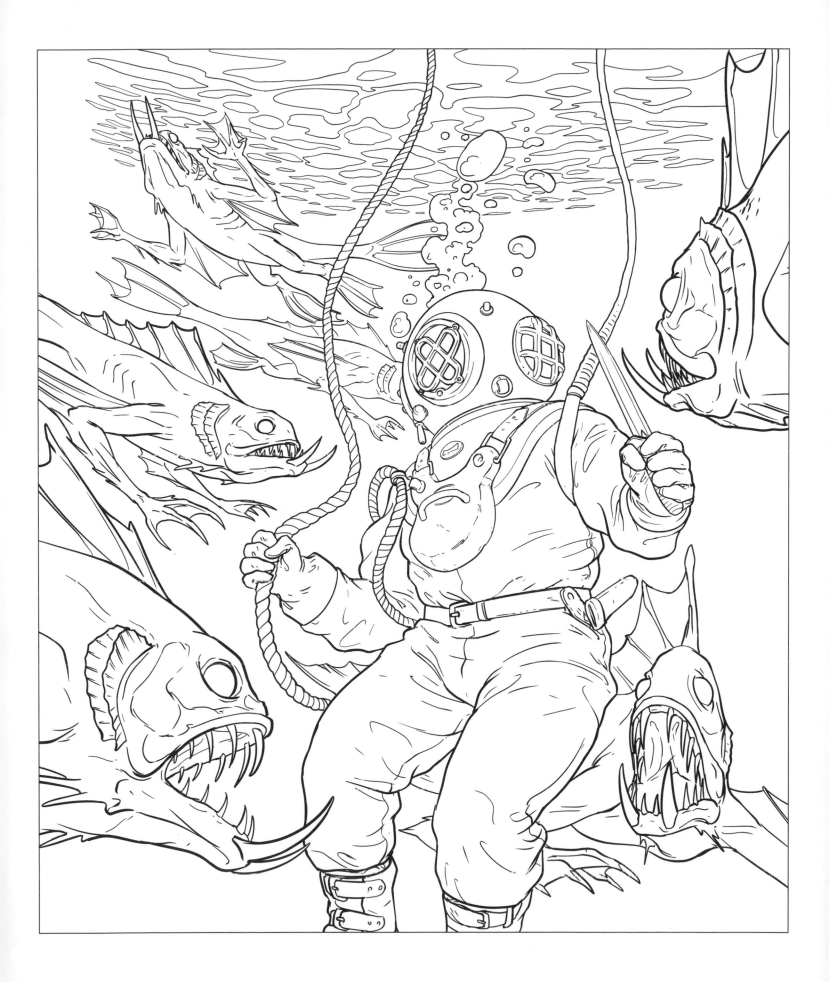

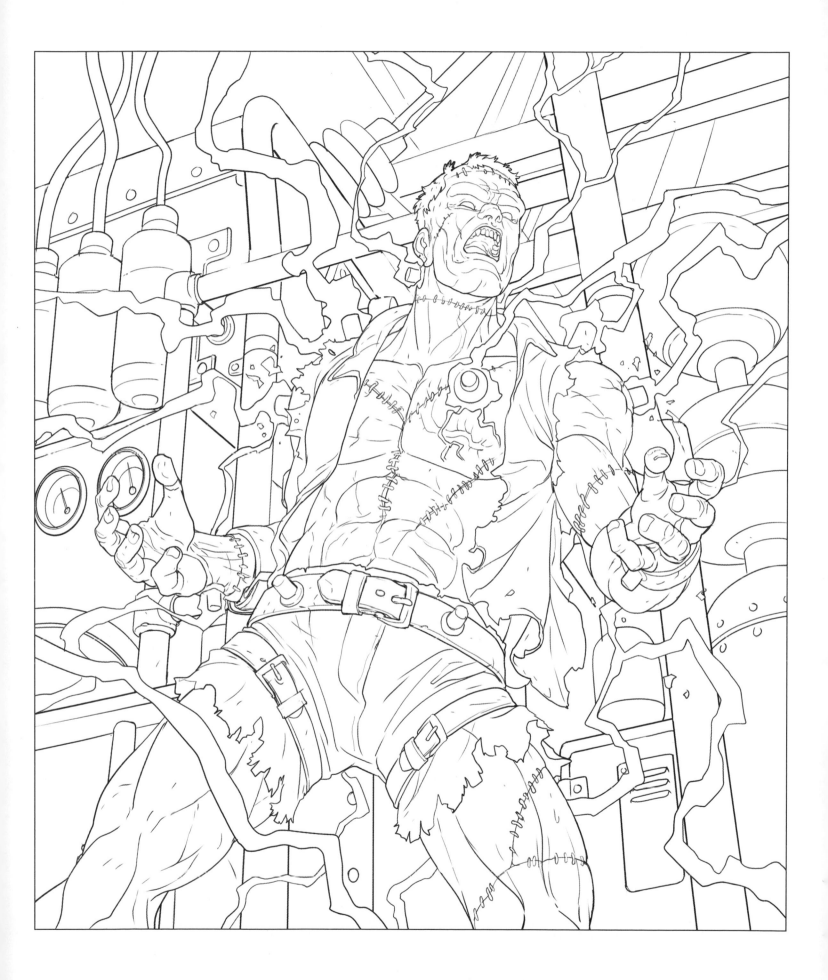

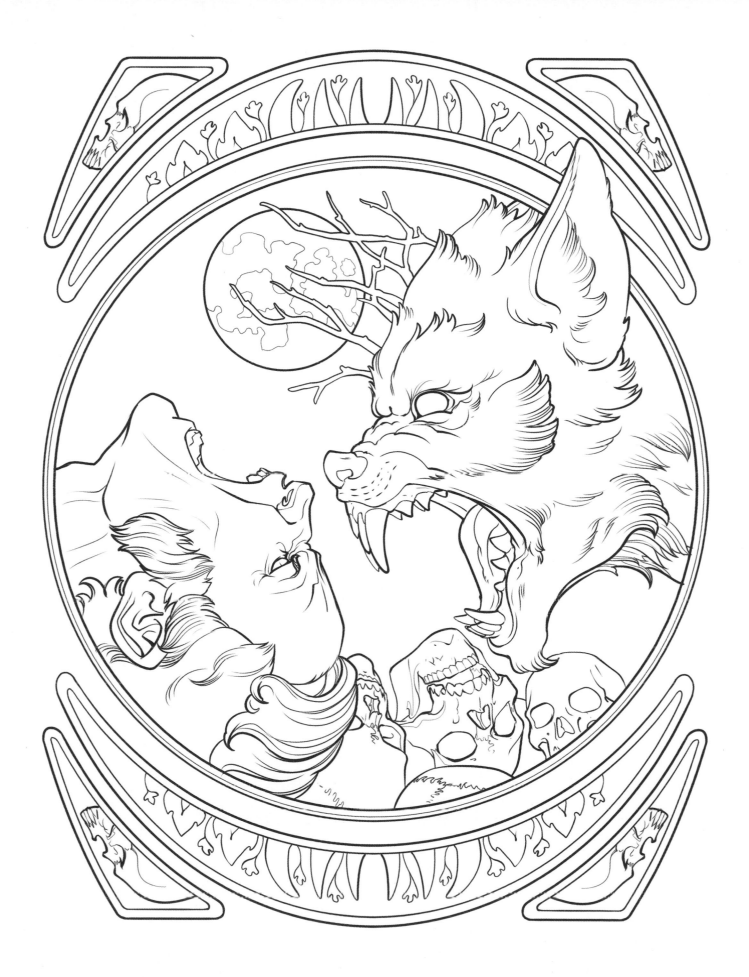

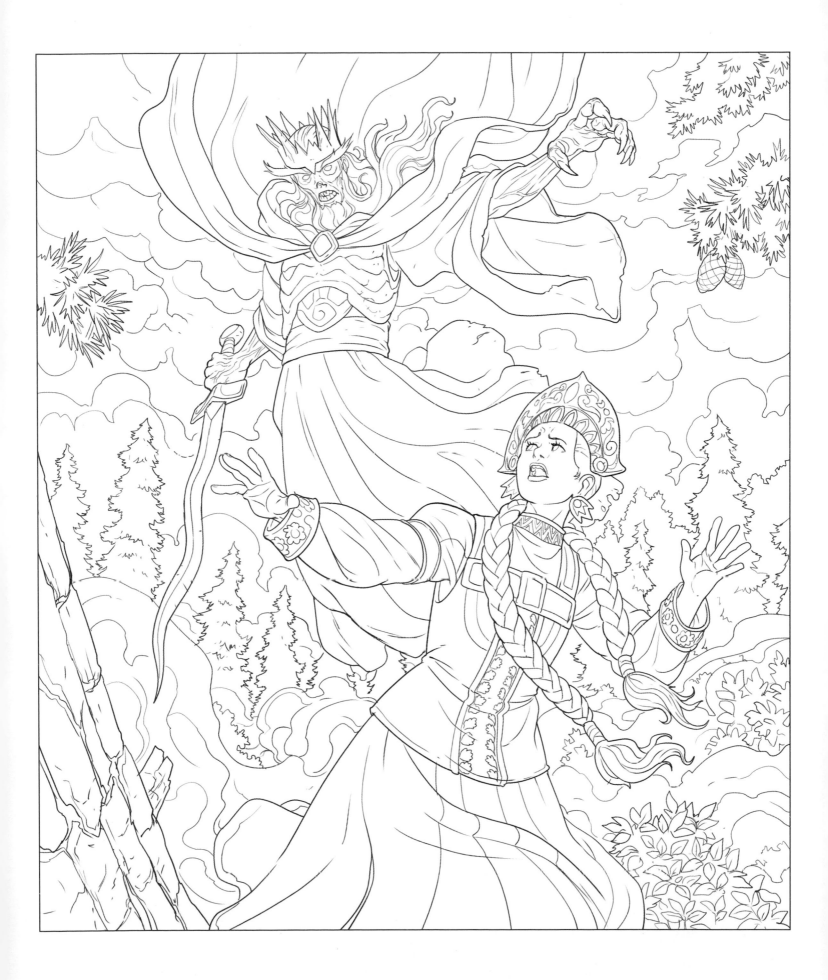

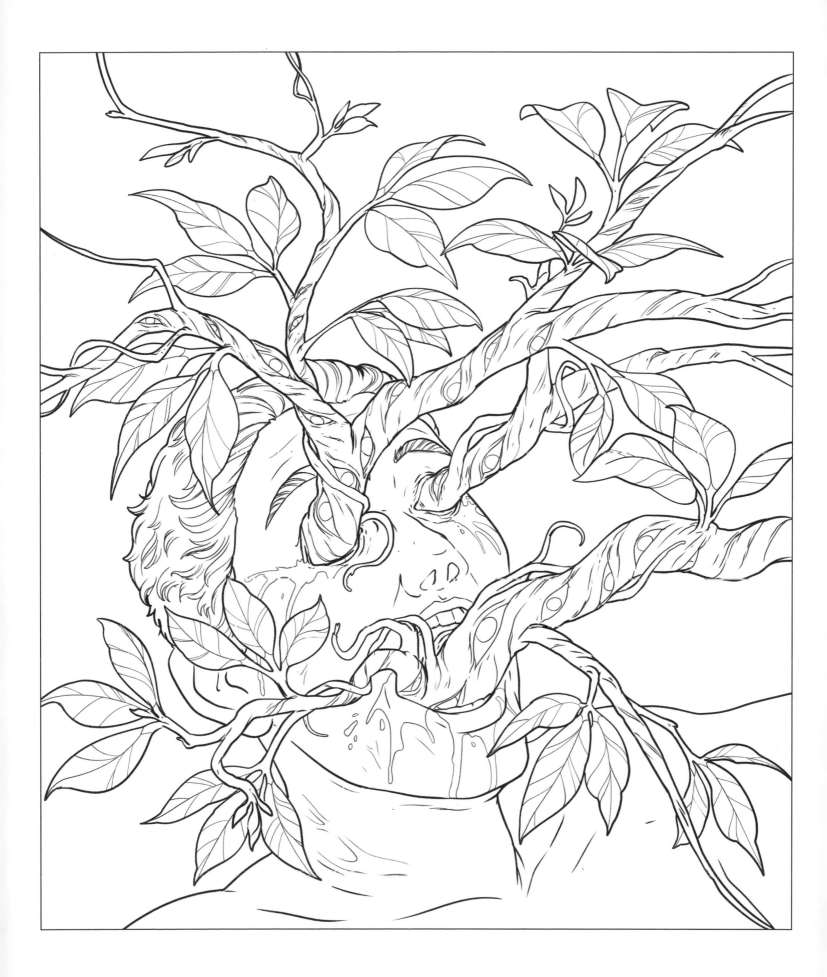

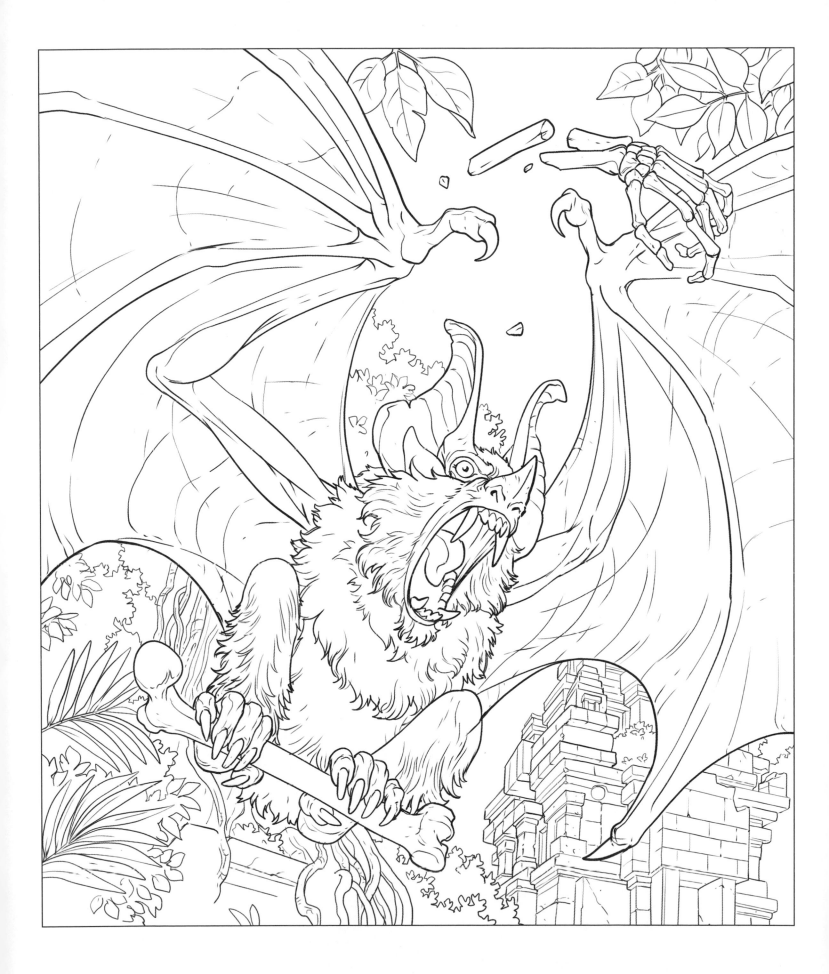

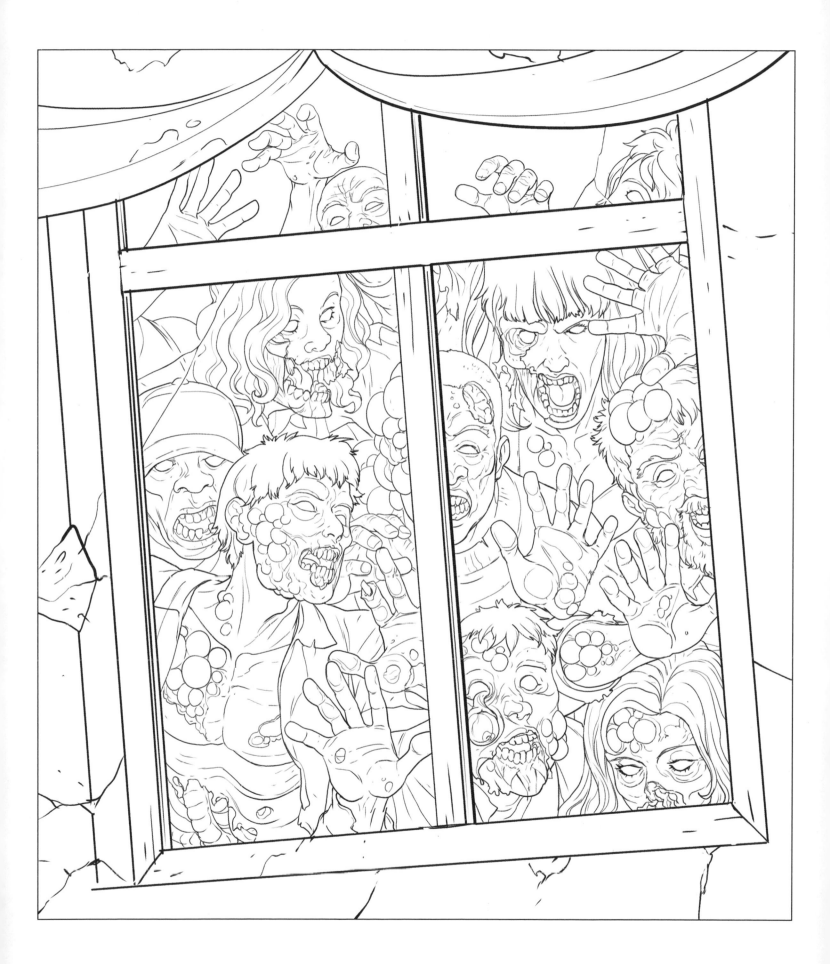

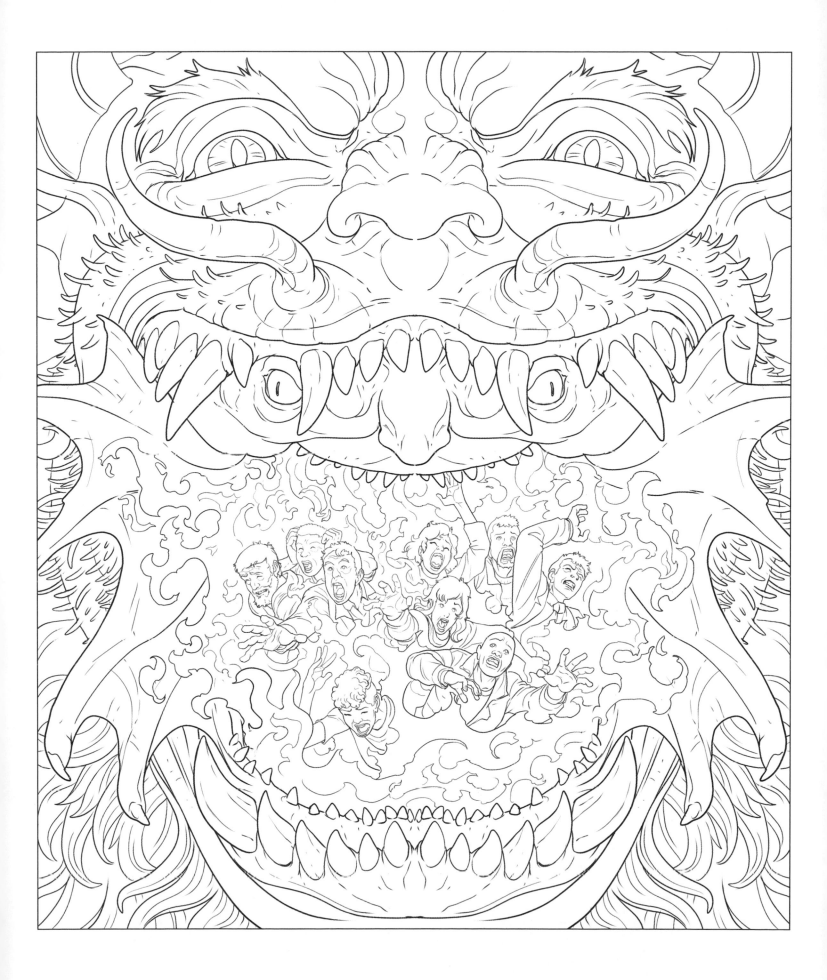